IMAGES
*of* *America*

# CARMEL VALLEY

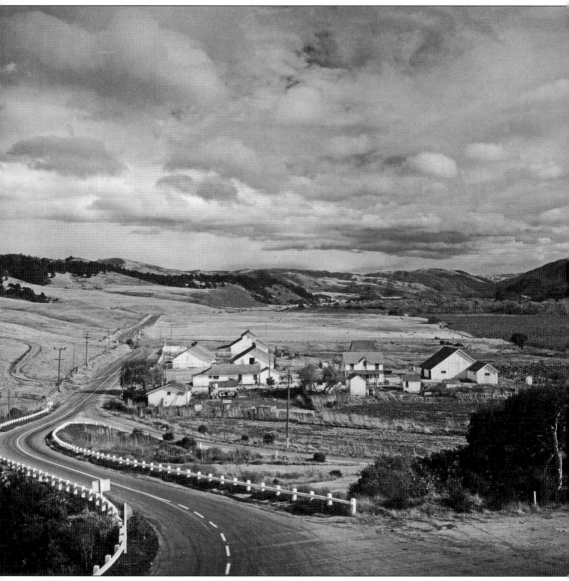

This pastoral scene portrays the final era of the Hatton Lower Dairy, located at the junction of Carmel Valley Road and Highway 1. The photograph was taken in 1947, just before this and similar Carmel Valley family-run dairy and farming enterprises were removed to make way for modern progress. Once owned by the family of pioneer William Hatton, the site now forms part of the Carmel Rancho and Barnyard Shopping Centers. (Photograph by George Seideneck; courtesy Monterey Public Library, California History Room Archives, Harbick Collection.)

ON THE COVER: A party of friends pauses for the camera during some high jinks in this 1886 scene at Eagle Camp, located east of present Carmel Valley Village. Following a wagon ride from Salinas or Monterey to Eagle Camp (now Camp Steffani), parties often spent a week or more by the Carmel River, fishing and "rusticating," or taking in the country atmosphere. (Courtesy Monterey County Historical Society, Inc.)

IMAGES
*of America*

# CARMEL VALLEY

Elizabeth Barratt and the
Carmel Valley Historical Society

ARCADIA
PUBLISHING

Published by Arcadia Publishing
Charleston SC, Chicago IL, Portsmouth NH, San Francisco CA

Printed in the United States of America

Library of Congress Control Number: 2009929236

For all general information contact Arcadia Publishing at:
Telephone 843-853-2070
Fax 843-853-0044
E-mail sales@arcadiapublishing.com
For customer service and orders:
Toll-Free 1-888-313-2665

Visit us on the Internet at www.arcadiapublishing.com

*To all the people of Carmel Valley who over the ages have been guardians of this magnificent enclave of serene beauty and beckoning ruggedness.*

# CONTENTS

# ACKNOWLEDGMENTS

I extend my heartfelt gratitude to the following individuals who were so generous in sharing their time, images, and input: Kate and Pat McAnaney, Karen and Russel Wolter, Katrin Smith, Linda Yamane, Claudia Salewske, Kent Seavey, Meg Clovis, Rick Wilkerson, Ellsworth Gregory, June Taylor, Ruth Peace, Hunter Lowder, and Frank Tarantino. I am particularly indebted to Dennis Copeland of the Monterey Public Library's California History Room for his countless hours of help, insight, and advice. Thanks also to Denise Sallee and Rose McLendon of the City of Carmel's Harrison Memorial Library Henry Meade Williams Local History Room, Jim Conway, Chalet Catlin and Jeff Lanzman of the City of Monterey's Colton Hall Museum, Mary Housel and Jayanti Addleman of the Monterey County Free Libraries, and Mona Gudgel of the Monterey County Historical Society. I am indebted to John Castagna for his invaluable assistance and advice with photographs.

This book pays in part my long-standing obligation to those *doyennes* of Monterey County history who started me down the adventurous and meandering path of historic research decades ago: Amelie Elkinton, Enid Sales, Marcia DeVoe, and my mother, former Colton Hall Museum curator Dorothy Chesbro Ronald: *Requiescite in pacem.* All my gratitude for his long hours and devotion to turning out the perfectly scanned photograph goes to the chairman of the Carmel Valley Historical Society, who also happens to be my husband, my guy, and my best friend, Richard Barratt.

# INTRODUCTION

Archaeological findings indicate the first permanent peoples in Carmel Valley occupied village settlements beginning about 2,000 years ago. These early inhabitants consisted of two separate tribes. The Esselens lived near the upper course of the Carmel River in the Tularcitos and Tassajara areas and into the Santa Lucia Mountains. The Rumsen, a division of the Ohlone (or Coastanoan) language group, lived from mid-valley to the mouth of the Carmel River and south along the coast. Both native groups were small in population, living in groups or tribelets of 100 to 150 people who confined their lives and activities to within about a 30-mile radius. The natives dressed in woven grass fibers and animal skins and lived by hunting, fishing, and gathering acorns, nuts, and berries.

Although Sebastian de Vizcaíno briefly explored the mouth of the Carmel River in 1602 during his discovery of Monterey Bay, Spanish occupation of the region did not begin for another 168 years. Commandant Gaspar de Portolá's 1769 trek northward from San Diego failed to recognize the Monterey Bay of Vizcaíno's description when the expedition passed by, continuing north to discover San Francisco Bay. Realizing their error, a joint party returned the following year. Padre Junípero Serra and engineer Miguel Costansó came by sea, meeting a land contingent led by Portolá. His party of 20 included Padre Juan Crespí, Don Pedro Fages, Catalonian volunteers, Leather Jacket soldiers, and a few Native Americans. The men rediscovered the Monterey Bay they thought had been lost, and on June 3, 1770, in the name of the Spanish crown, the hardy group began the occupation of Alta California. Near the shores of Lake El Estero overlooking Monterey Bay, they established the Presidio of Monterey and Mission San Carlos Borromeo. In 1771, the Monterey mission was moved to a spot near the mouth of the Carmel River and renamed Mission San Carlos Borromeo del Río Carmelo, a name today often shortened to Mission Carmel.

Mission ranch acreage soon came under cultivation, starting at the mouth of Carmel Valley and moving inland, following the life-giving waters of the Carmel River. The farmland was occupied and tended by the Mission Indians, who cultivated parcels allotted for barley, wheat, and maize. Livestock raising included cattle and hogs, with later additions of sheep and goats. Beginning in 1782, the padres tapped the Carmel River to water crops, making them the first in the region to introduce irrigation. Except for drought years, the added water use enabled greater crop production than at many other missions. During this early period, the Carmel area was visited by several expeditions whose leaders were eager to discover what life was like in the new territory. The French explorer Jean François de La Pérouse toured Mission Carmel and environs while on a 1786 voyage. He left a written account of his stay, describing the hardworking and closely guarded life of Carmel's Mission Indians. In 1791, while accompanying Alejandro Malaspina's Spanish scientific and ethnographic expedition, artist José Cardero made numerous drawings showing local Native Americans at various daily activities. The next year, British commissioner George Vancouver visited the mission and Carmel Valley, later recounting the living conditions he observed.

First under Spain, then as part of Mexico (1824–1846), large Carmel Valley land grants were bestowed on several individuals. The Jose Manuel Borondas were the first permanent white family to settle in the area when they moved into an adobe on their Rancho los Laureles in 1840, one year after receiving the grant. Mrs. Juana Boronda is credited with introducing the now-famous Monterey Jack cheese to the area. Other land grants were Rancho los Tularcitos (1834), Rancho San Francisquito (1835), Rancho Potrero de San Carlos (1837), and Rancho Cañada de la Segunda (1839).

Following California's admission to the United States in 1850, Carmel Valley life remained rural into the next century. Dairies, orchards, farming, and cattle ranching were the area's main industries. Only a few farm families lived in the valley, where the daily work life meant multiple chores for workers and family members. Occasional dances and holiday celebrations were cause for friendly gatherings and sharing of the latest news.

Scottish writer Robert Louis Stevenson visited Carmel Valley on a camping trip in 1879. His observations of the valley's peaceful, pastoral nature, published in an essay, "The Old Pacific Capital," foretold the changes the pleasing landscape would undergo in the name of progress.

Progress by one individual in Carmel Valley began in 1874 when Oakland's 15th mayor, Nathan Spaulding, purchased the sprawling Rancho los Laureles. The innovative rancher introduced modern irrigation methods and rail fencing and blasted an 8-mile-long ditch and reservoir to provide additional water for his crops and dairy cattle. It was also under Spaulding's ownership that the magnificent, 130-year-old eucalyptus trees that line Boronda Road at Carmel Valley Road were planted. The trees are now on the National Register of Historic Places.

During the 1880s, Spaulding's employee housing became a resort lodge for the next ranch owner, the Pacific Improvement Company, the holding company of the Big Four of railroad fame. Besides its large dairy business, the company operated an "outpost" at its Los Laureles Lodge as an extension stay for guests of its Hotel Del Monte in Monterey. The lodge became a rustication spot for day-trippers and hunting parties who made the wagon trip over from Monterey along the steep, winding Laureles Grade. Tassajara Hot Springs, once a Native American healing locale situated far into the mountains of Upper Carmel Valley, also became a favored tourist spa, offering leisurely soaks in mineral springs and evening entertainment to guests who made the lengthy, arduous wagon trek and often stayed for weeks.

Although the 6,625-acre Rancho los Laureles remained largely intact until the 1920s, by then most of Carmel Valley's other large ranchos were sold and the land divided up into smaller parcels, often for extended family members. Today's roads, lanes, and locales in Carmel Valley retain the names of industrious families from the settler period: Boronda, Meadows, Ford, Hitchcock, Atherton, Martin, Wolter, Sargent, Berwick, Hatton, Nason, Berta, Steffani, Schulte, Holman, Blomquist, Tomassini, Scarlett, and Martin, to name just a few.

Development accelerated during the 1920s when the first subdivision, Robles del Rio, created a colony of summer cabins for out-of-the-area families. Equestrian ranches, guest lodges, and shopping centers appeared, along with an influx of the rich and famous who found Carmel Valley's salubrious climate and relaxing atmosphere to their taste. When Carmel Valley Road was widened, a nod to increased year-round population, the change also signaled a shift in the valley's previously pastoral character.

In recent decades, local concern has grown over the demolition of old barns, homes, buildings, and trees from Carmel Valley's earlier era as public interest has increased in preserving the area's unique historic features. The growth of vineyards and resorts in Carmel Valley in recent decades has had a positive effect in enhancing the local economy while preserving the area's rustic natural appeal.

The Carmel Valley Historical Society's motto, "Preserving our Past for the Future," bespeaks its dedication to protecting and maintaining the rich heritage of the bucolic valley for generations to come.

*One*

# Early Inhabitants

Along the course of the Carmel River, life was lush with fish, animals, and vegetation. The first dwellers of Carmel Valley, the Esselen in the upper valley and the Rumsen in the lower reaches, led a largely self-sustaining existence. The climate was congenial, providing quantities of seasonal food gathered by men, women, and children. The tribelets lived by a yearly cycle, collecting acorns and grasses; catching fish from the river with nets, harpoons, and basket traps; and hunting for deer and fowl along the valley floor. For coast dwellers, shellfish such as mussels, clams, and crabs were available in great seasonal supply, as was salmon and waterfowl at the mouth of the river. Even beached whales were reportedly consumed with gusto.

For thousands of years, these native inhabitants led a relatively stable way of life, living in dome-shaped woven rush huts in *rancherías*, or villages, which they moved occasionally for sanitary reasons. They migrated between the coast and valley according to the season. For dress, the men either went naked or wore a short covering of rabbit or similar skin; the women dressed in an apron made of twisted cords reaching to the knees. Cultural finds at Tassajara and at a Carmel River site show these early peoples used tools such as mortars, pestles, scrapers, and awls. An Esselen rock shelter and cave art in the form of carefully drawn images of hands has been found at remote locales in the Los Padres Forest. Linguistically the groups spoke so many distinct dialects that residents of one village might not recognize the language of their neighbors.

After Mission San Carlos Borromeo del Rio Carmelo was founded in 1771, Spanish padres began their missionary quest to gather members of neighboring tribal groups, convert them to Christianity, and bring them to live in the mission compound. There the neophytes were put to work doing chores or making crafted goods. Others were sent into the valley to cultivate the mission-controlled farms. For these first, free peoples of Carmel Valley, life would be changed forever.

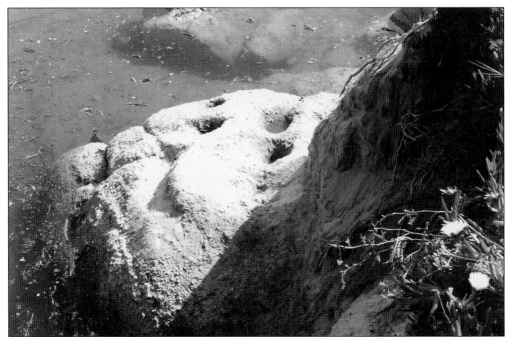

This cluster of ancient bedrock mortars is nestled into the base of a cliff that edges the Carmel River State Beach at Stewart's Cove, where the Carmel River meets the Pacific Ocean. A severe 1993 winter storm revealed the find, surprising archaeologists with its evidence of previously undocumented native activity at the site. (Photograph by Richard Barratt.)

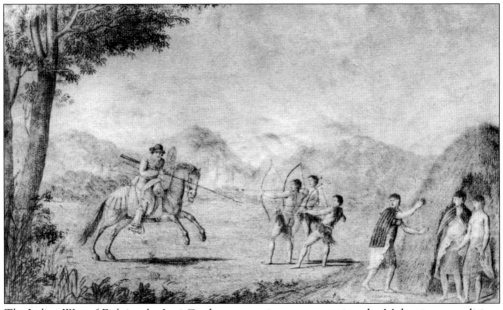

*The Indian Way of Fighting,* by José Cardero, an artist accompanying the Malaspina expedition, depicts a Spanish soldier on horseback confronting Rumsen natives. While several defend themselves with bows and arrows, others stand at the entrance to a *ruc,* or domed rush hut. Cardero's 1791 drawings are believed to be the earliest views of the Presidio of Monterey and Mission Carmel. (Courtesy Monterey Public Library, California History Room Archives.)

In this 1791 sketch, *Indians of Monterey*, artist José Cardero depicts a barefoot, bare-breasted Rumsen woman wearing native dress consisting of two skirts, one in back and one in front, both bound at the waist. A fur cape over her shoulders offers warmth, while a shell necklace and earrings provide decoration. (Courtesy Monterey Public Library, California History Room Archives.)

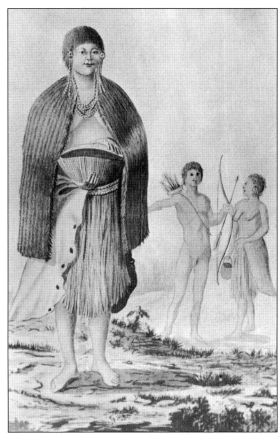

In 1786, French navigator and scientist Jean François Galaup de la Pérouse became the first foreigner to visit Mission Carmel. This drawing, attributed to Tomás de Suria, shows Pérouse entering the mission quadrangle. He compared the neophytes' regimented living conditions to a slave colony. They were fed *atole* (barley gruel) or *pozole* (wheat, corn, pea, and bean stew) instead of their native foods. (Courtesy Monterey Public Library, California History Room Archives.)

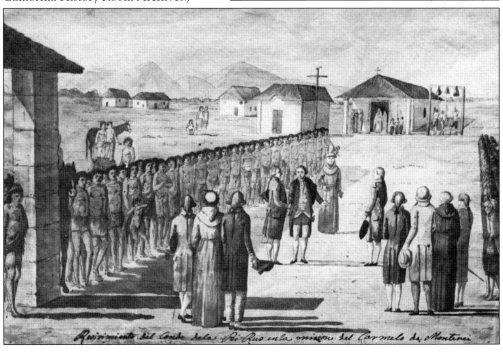

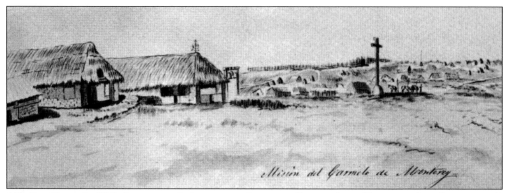

*Mission Carmel, 1791* depicts stark living conditions still prevalent 20 years after the mission's founding. Clergy lived, worked, and worshiped in thatched-roof structures (foreground) while neophytes occupied huts, seen in the rear. Mission life was conducted inside the walled quadrangle. Its central focus was the hewn cross erected by Padre Serra, who had died six years before Cardero drew this scene. (Courtesy Monterey Public Library, California History Room Archives.)

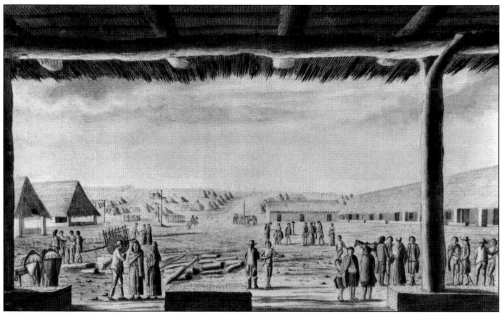

This pen-and-ink drawing, which José Cardero titled *Convent Church*, shows European visitors from the 1791 Malaspina expedition being greeted by Native Americans and padres during a visit to Mission Carmel. A pile of timber in the foreground indicates progress was being made on additional buildings inside the church compound. (Courtesy Monterey Public Library, California History Room Archives.)

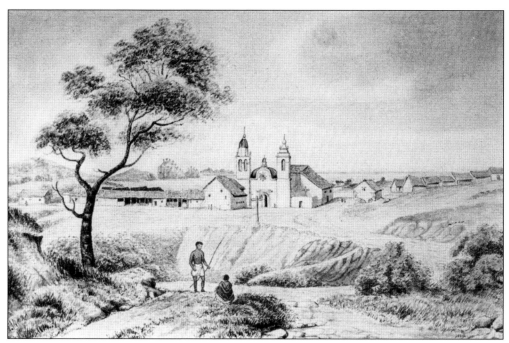

An 1827 watercolor, *Mission of San Carlos-Upper California*, attributed to Capt. William Smyth of the Royal Navy, portrays an idealized life for Carmel Mission Indians. Dormitories and workshops adjoin the stone church, with homes for neophyte families visible on a slight hill behind. Two natives placidly fish in the Carmel River. Secularization will soon scatter them, and their routine life, forever. (Courtesy Monterey Public Library, California History Room Archives.)

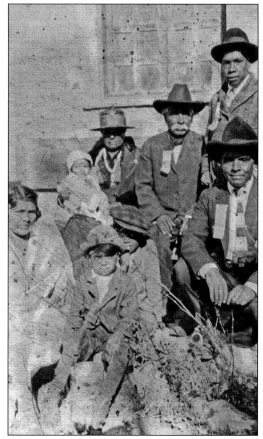

The Onesimo family was descended from Juan Onesimo, a Mission Indian who helped build Mission Carmel. Shown posing for a 1920s group photograph in Carmel Valley are, from left to right, the following: (first row) Juan (young son); William (child behind Juan); and Alejandro (son); (second row) María (daughter); Manuela (mother) holding Margaret (María's daughter); Manuel (father); and Bertoldo (standing). (Courtesy Monterey Public Library, California History Room Archives.)

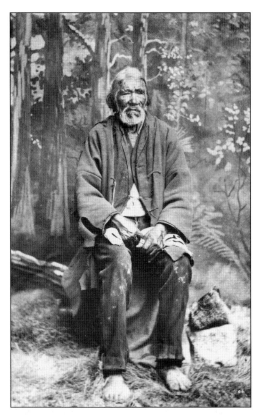

Old Gabriel, said to have been the oldest remaining Carmel Mission Indian, poses for a formal sitting in this 1880s portrait. An 1889 biographical sketch claimed Gabriel was present at the arrival of Padre Serra. He was also credited for helping to erect the adobe walls of the mission's first chapel in 1771–1772. (Courtesy Colton Hall Museum, City of Monterey.)

An accomplished stone-cutter, Old Gabriel poses by Mission Carmel, which he helped construct. Gabriel outlived six wives and ended his days in the Monterey County Hospital. Although his birth date is unknown, Old Gabriel died at an estimated age of 145–151 on March 14, 1890. He is buried in the cemetery at Mission Carmel, where a weathered headstone marks his grave and his astounding age. (Courtesy Monterey County Free Libraries.)

# *Two*

# Mission San Carlos Borromeo del Rio Carmelo

By July 1771, Monterey's unreliable water supply and insufficient crop acreage caused Padre Serra to move the mission to the mouth of Carmel Valley. A crew of Mission Indians and soldiers went to work building a chapel, granary, boys' living section, kitchen, stockade, guardhouse, and corrals. On August 24, 1771, St. Bartholomew's Day, Padre Serra raised a hewn cross in the center of the new quadrangle. By Christmas, mission effects were transferred from Monterey and the new church was activated. Padres Serra and Crespí labored alongside the workers, held mass, fed the curious natives, and began to learn words in their language.

Mission San Carlos Borromeo del Rio Carmelo, the second mission founded in Alta California by Padre Serra, became headquarters for the mission system. He resided there unless traveling on foot to the other missions on administrative duties. Native American conversion, initially slow, grew to several hundred neophytes by Serra's death on August 28, 1784.

Mission prosperity reached its height under Padre Presidente Fermín Lasuén. By 1792, visiting Spanish naval officers Dionisio Alcalá Galiano and Cayetano Valdés reported a secure economy, with 770 neophytes, 1,193 head of major livestock, and 1,146 head of minor livestock. Land under cultivation provided sufficient staple food for the mission population. The cornerstone of the present church was laid in 1793 during Padre Lasuén's leadership. Completed in 1797 and built on the site of the original adobe chapel, it was the first California mission constructed of stone.

Following secularization in 1834, the mission fell into disuse. By 1849, visiting New York writer Bayard Taylor found the outbuildings and walls broken down. A solitary caretaker unlocked the weather-beaten church doors to show him the still-intact interior. By 1850, the roof had collapsed. Monterey *alcalde* Walter Colton observed, "The only being I found in it was a large white owl, who seemed to mourn its fall." By 1857, visiting artist Henry Miller wrote that squatters occupied the church: "Some saints, as large as life, cut in wood and painted, are still to be seen; they are riddled with bullets, having served as a target."

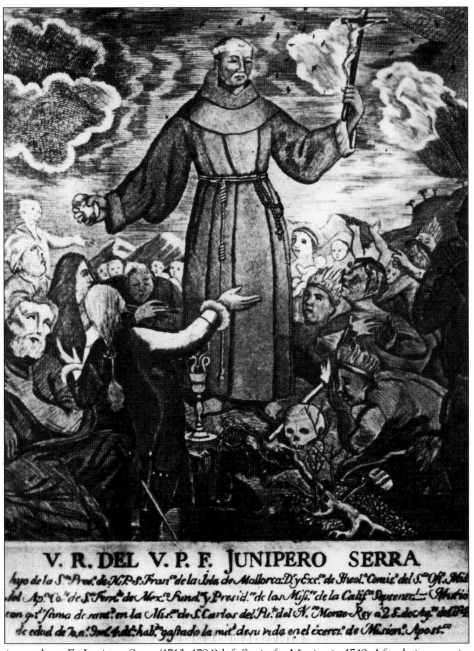

V. R. DEL V. P. F. JUNIPERO SERRA

*hyo de la S.ᵗᵃ Prov. de N.P.S. Fran.ᶜᵒ de la Isla de Mallorca D.ʳ y Exᶜᵗᵒ de Theol. Comiſ.ᵗ del S.ᵗᵒ Ofᶜ.ᵗ Miſ.ⁿᵉᵗ del Apᵗᶜ Col.ᵗ de S.ᵗ Ferⁿ.ᵗ de Mex.ᶜᵒ Fund.ʳ y Preſid.ᵗᵉ de las Miſ.ˢ de la Calif.ᵗ Septenᵗᵗᵃˡ — Murio con gͭᵗ fama de ſant.ᵈ en la Miſ.ⁿ de S. Carlos del Puᵗᵒ del N.ᵗ Monte Rey a 28 de Agᵗᵗ del 84ᵗ de edad de 70 a.ˢ 9 mͤˢ 4 diͤˢ hab.ᵗ gaſtado la mit.ᵗ de ſu vida en el exercᵗ de Miſion.ˢ Apoſt.ˢ*

Majorcan-born Fr. Junípero Serra (1713–1784) left Spain for Mexico in 1749. After being appointed *padre presidente* of the Missions of Lower and Upper California in 1767, he journeyed north on foot, first establishing Mission San Diego, then Mission San Carlos Borromeo del Río Carmelo (often shortened to Mission Carmel). This depiction shows the venerable Franciscan surrounded by the faithful as he raises a hand in blessing. The drawing appeared in Padre Francisco Palou's biography of Serra, *Relación histórica*, published in 1787 in Mexico City. Padre Palou's volume was the first written in California. In 1985, Pope John Paul II declared Junípero Serra venerable, and in 1988, the Franciscan padre was beatified. (Courtesy Monterey Public Library, California History Room Archives.)

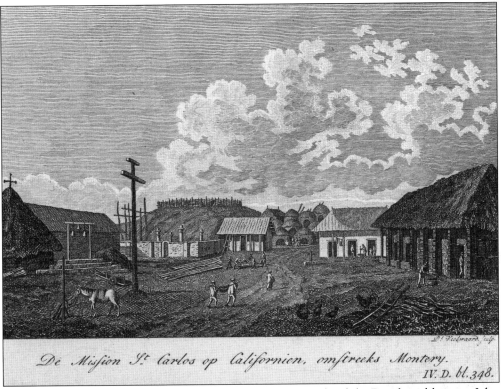

*De Mission St Carlos op Californien, omstreeks Montery.*

IV. D. bl. 348.

*Mission San Carlos de Borromeo*, a drawing based on a *c.* 1798 sketch by British midshipman John Sykes, depicts a cluster of thatched-roof buildings in the mission quadrangle. Stone walls behind Father Serra's large hewn cross (left) mark the beginnings of the final mission church, started nine years after his death. (Courtesy Monterey Public Library, California History Room Archives.)

Local artist Ferdinand Burgdorff photographed this evocative scene, "Carmel River," showing the stream flowing past an unpopulated area near the Carmel Valley mouth. The 1908 view is reminiscent of a description penned by Padre Palou over a century earlier. He wrote that a year-round supply of running water made the area ripe for planting crops and ideal for pastureland. (Courtesy Harrison Memorial Library.)

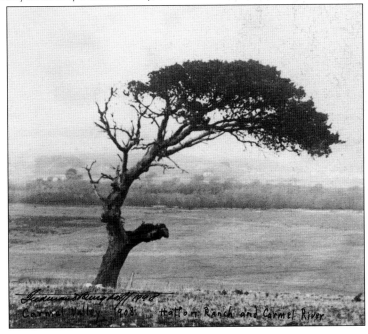

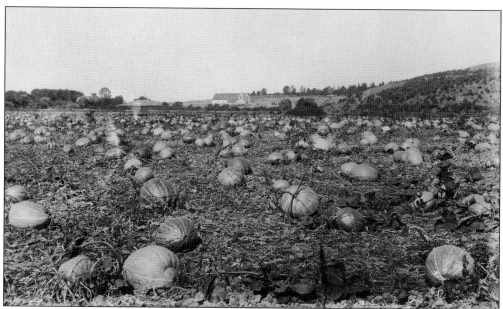

Mission Carmel provides a picturesque backdrop to a field of squash growing in a former mission garden field. Padre Pedro Font visited the mission grounds in 1776 with the second De Anza expedition. Noting the area's cool climate, he reported that padres grew cauliflower, lettuce, artichokes, and herbs, with fields of legumes, barley, and wheat growing near the Carmel River. (Courtesy Monterey Public Library, California History Room Archives.)

This Louis Slevin scene, "Plowing the Field in the Back of Carmel Mission," captures workers toiling behind the lonely mission in the early years of the 20th century, not unlike the Mission Indian laborers a century earlier. The hills at the mouth of Carmel Valley are visible in the background. (Courtesy Monterey Public Library, California History Room Archives.)

In 1879, Robert Louis Stevenson wrote of the abandoned Carmel Mission, "The church is roofless and ruinous, sea-breezes and sea-fogs and the alternation of the rain and sunshine daily widening the breaches and casting the crockets from the wall." Calling it "a quaint specimen of missionary architecture," he opined that "neglect and abuse have been its portion." (Photograph by C. W. J. Johnson; courtesy Monterey Public Library, California History Room Archives.)

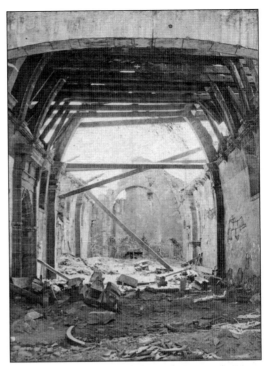

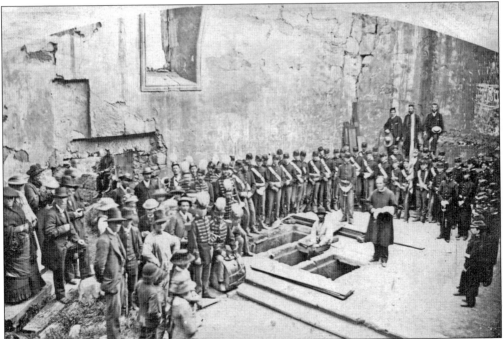

In 1882, after rubble was cleared, Father Serra's grave was revealed beneath the floor in front of the main altar. Here Fr. Angelo Casanova and clergy reverently surround the tomb, being exhumed for the first time since the burial. The tombs of Fathers Crespí, Lasuén, and López were also rediscovered alongside Father Serra's resting place. (Photograph by C. W. J. Johnson; courtesy Monterey Public Library, California History Room Archives.)

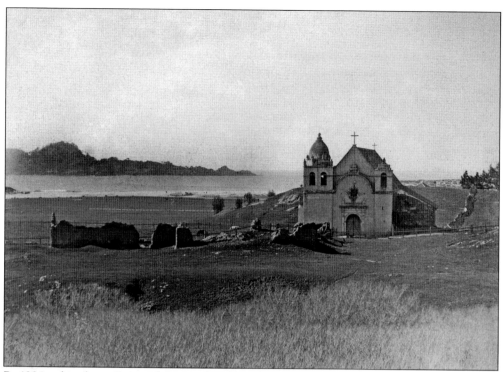

By 1884, a shingle roof covered the nearly collapsed mission, shown here with ruined adobe walls in front and Carmel Bay in the background. Padre Font had praised the setting in 1776: "It is a most beautiful site and pleasing to the view, because it is so near the sea and in a country so charming and flower covered that it is a marvel." (Courtesy Monterey Public Library, California History Room Archives.)

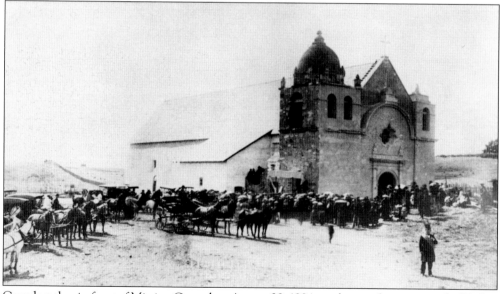

Crowds gather in front of Mission Carmel on August 28, 1884, to observe the centennial of Father Serra's death and the beginnings of Father Casanova's restoration of the old church. (Photograph by C. W. J. Johnson; courtesy Monterey Public Library, California History Room Archives.)

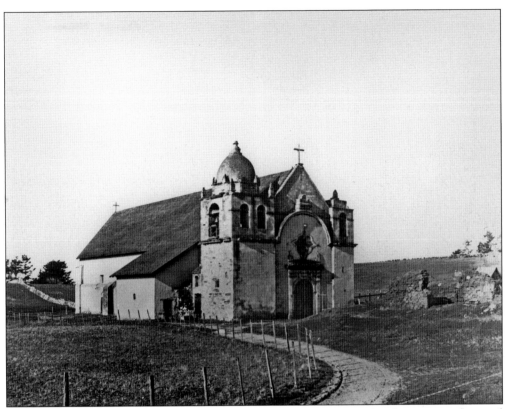

This 1898 scene by J. K. Oliver shows low adobe walls on the mission's right, the remains of original buildings. Photographers, artists, and writers personified the old church, romantically portraying it as a silent witness watching the centuries pass as it guarded the venerable tomb of its founder, Padre Junípero Serra. (Courtesy Monterey Public Library, California History Room Archives.)

Restored to use, the simply adorned altar and interior of Mission Carmel are shown as they appeared in a 1902 photograph. The sanctuary's arched ceiling feature was unique in Alta California mission architecture. (Courtesy Monterey Public Library, California History Room Archives.)

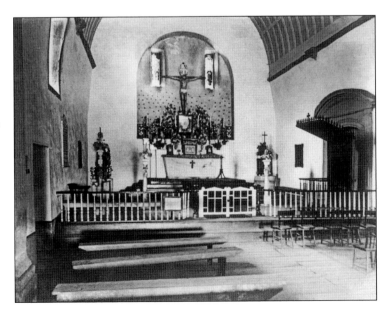

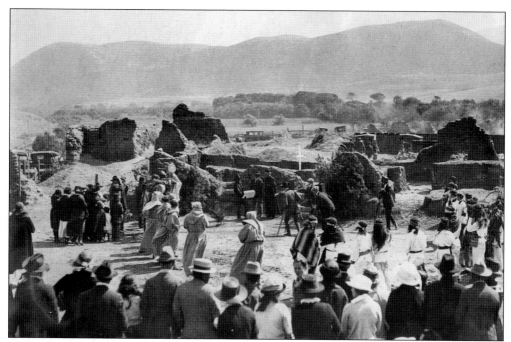

Under Fr. Ramon Mestres, pilgrimages to mark special occasions were often held at Mission Carmel. Here a group of the faithful gathers outside the church on October 21, 1921, to observe a cornerstone laying. (Courtesy Harrison Memorial Library.)

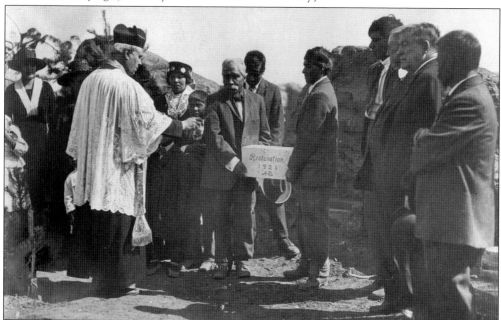

Manuel and Alejandro Onesimo, Rumsen Indian descendants whose ancestor was baptized by Father Serra, are photographed with Fr. Ramon Mestres as they prepare to lay the cornerstone in solemn ceremony at the mission on October 21, 1921. Father Mestres, an expert in Spanish colonial architecture and history, began a meticulous restoration and reconstruction process of the original buildings. (Courtesy Harrison Memorial Library.)

Artist-sculptor Jo Mora designed a travertine marble and bronze cenotaph as a memorial to Father Serra. In 1924, it was placed inside the first restored room of the original mission quadrangle and named the Serra Memorial Chapel. The cenotaph shows a reclining Serra surrounded by Fathers Crespí, Palou, and Lasuén. (Courtesy Harrison Memorial Library.)

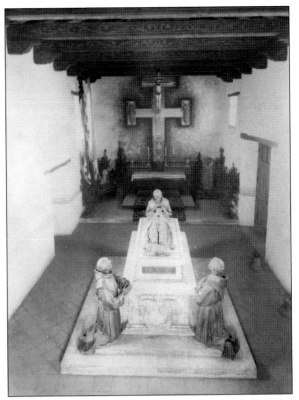

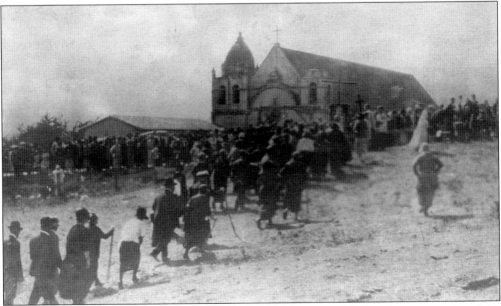

Crowds hasten to Mission Carmel on October 12, 1924, to attend dedication ceremonies of the restored chapel room and to witness the unveiling of its main feature, the exquisitely sculpted Jo Mora cenotaph. The event included a seven-day pageant scripted by Father Mestres and Perry Newberry in which 750 costumed performers reenacted historic events in the mission's past. (Courtesy Harrison Memorial Library.)

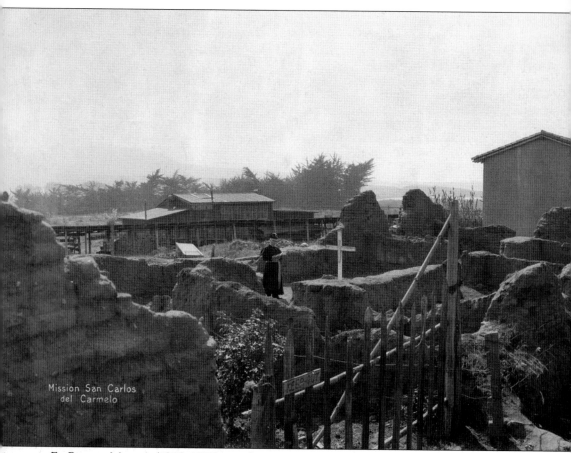

Mission San Carlos
del Carmelo

Fr. Ramon Mestres (1865–1930) stands next to a crumbling adobe wall adorned with a cross marking the location of Father Serra's cell in this 1926 panoramic photograph by James D. Givens. Restoration of the Mission Carmel grounds was underway, as indicated by the rebuilt mission church and Serra Memorial Chapel, center rear. The church during this period is still covered by the inappropriately designed 1884 shingle roof, which had been added to protect the structure from further collapse. Historically accurate restoration efforts of the church and its connecting

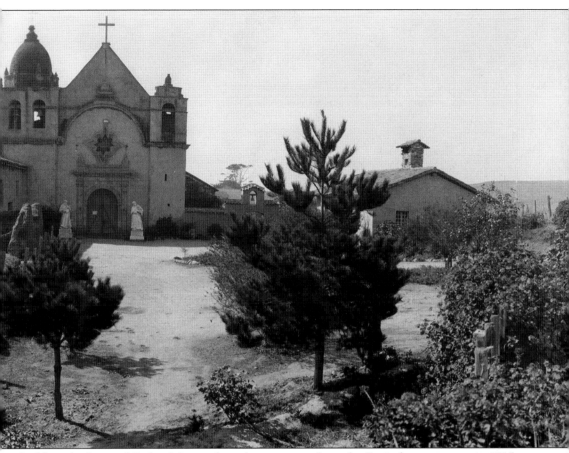

buildings had earned Father Mestres formal recognition from the Spanish government in 1915, when King Alfonso XIII awarded him membership in the Royal Order of Isabella. Following Father Mestres's death, Sir Harry Downie continued and completed the restoration process. The historic church was reactivated as a functioning parish in 1933 and has become a popular tourist attraction. (Courtesy Monterey Public Library, California History Room Archives.)

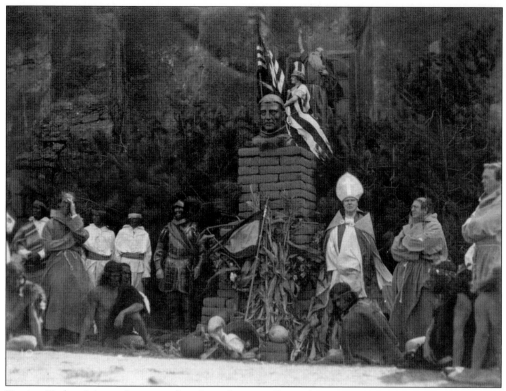

During Father Mestres's tenure, local residents in Spanish-era costume participated in many pageants commemorating saints days and holy days at Mission Carmel. In this event, held October 21, 1921, at a cornerstone laying, participants reenacted the roles of padres, Native Americans, soldiers, and Spanish citizens who figured in the mission's past. Funds from the various events helped finance restoration efforts. (Courtesy Harrison Memorial Library.)

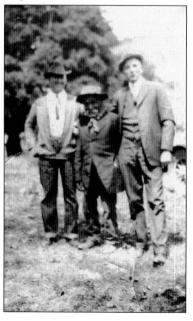

"Sordo," or Bernabé Onesimo, poses around 1920 in Carmel Valley with Stanley Ollason (left) and Bob Stirling. Friends called Bernabé "Sordo," the Spanish word for deaf, because of his poor hearing. He had excellent eyesight and was credited with an acute ability to spot fish in the Carmel River from a long distance. (Courtesy Russel and Karen Wolter Collection.)

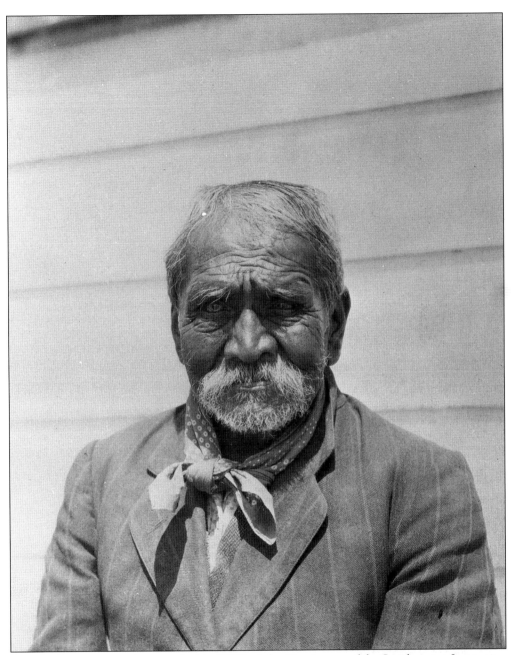

Bernabé Onesimo was photographed in 1928 by John Harrington of the Smithsonian Institution while documenting the life of local Native American descendants. Bernabé's mother, a Salinan Indian from Mission San Antonio, became Juan Onesimo's wife after her husband was killed. Juan raised Bernabé as his own son in the family's Carmel Valley home. Bernabé was a wood carver who enjoyed creating pictures of deer on tree trunks. He would never ask for work and had no regular job. When in need of money, he would go to the Hatton Ranch, pick out tools, and go to work on whatever needed doing at the time. Mrs. Hatton would pay him. Both the Hatton and Wolter families were good to Bernabé, always seeing he had a place to eat and sleep. (Courtesy Monterey Public Library, California History Room Archives.)

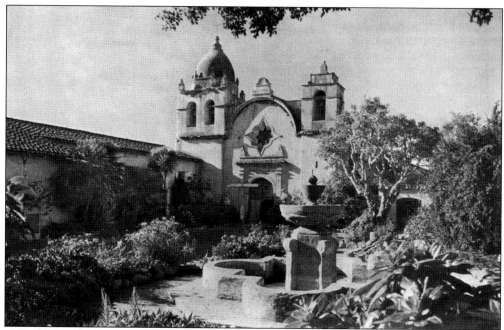

This 1950s postcard view shows a restored Mission Carmel. With manicured landscaping and decorated in sunset colors evocative of the sentimental *dolce far niente* look popular at the time of its restoration, the mission and grounds appear far more polished in appearance than during the bygone era of padres and neophytes. Pope John Paul II visited the Carmel Mission in 1987 during a tour of the United States. (Courtesy author.)

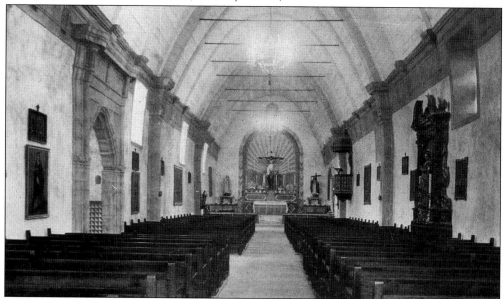

The interior of Mission Carmel is depicted in this 1950s postcard view. Some original statues and altar decorations remain from the church founding. On February 5, 1960, three decades after completion of its restoration, the church was designated a Minor Basilica by a Papal Bull issued by Pope John XIII. The historic mission is one of only 12 in the United States bearing the basilica designation. (Courtesy author.)

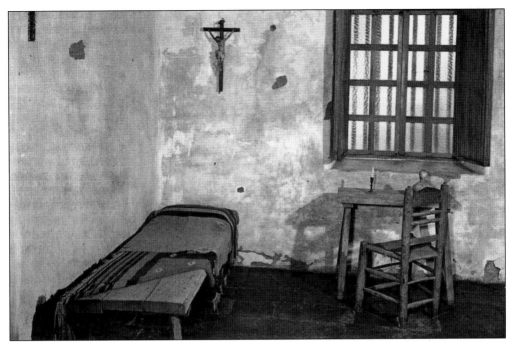

Padre Junípero Serra's restored cell at Mission Carmel reflects the sparse living conditions endured by the founder and first padre presidente of the California mission system. Serra died in this cell on August 28, 1784. Here the room is shown in a 1950s postcard view. The room's reproduction furnishings were made from original mission timbers. (Courtesy author.)

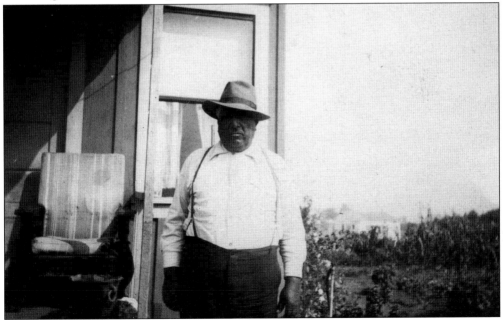

Juan "Charlie" Miranda, a descendant of Carmel Mission Indians, poses for a c. 1940 photograph on his Carmel Valley front porch. He was born at Los Borrecos Ranchería in Carmel Valley and was known to be living there in 1894. The ranch was later owned by Dwight Morrow. (Donated by Vic Mossop; courtesy Monterey Public Library, California History Room Archives.)

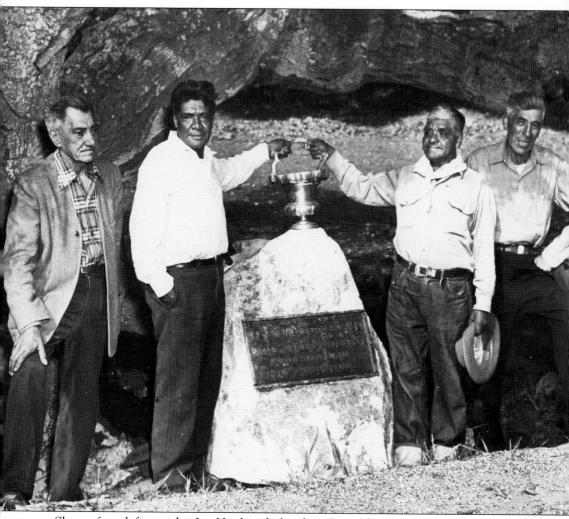

Shown from left to right, Joe Hitchcock, brothers Bertoldo "Bert" and Alejandro Onesimo (sons of Manuel "Panocha" Onesimo), and "Joe" Dolores Garcia pose by *El Encino de Descanso*, or "Resting Oak" during a 1953 plaque dedication ceremony. During the mission era, the coast live oak offered shade for Mission Indians passing along Carmel Valley Road. According to Joe Hitchcock's memoirs, Mission Indians who lived as far up the valley as Cachagua carried their dead to Mission Carmel for burial. In 1882, Fr. Angelo Casanova put a stop to the practice, and burials were instead taken to Monterey. While the *anderos*, or pall bearers, rested under the oak, they would carve a cross in the trunk, giving rise to a second name for the tree, *La encina de las cruces*, or "Oak of the Crosses." Hitchcock once counted 200 crosses on the tree. The long-dead oak, which originally grew near Wolter's Hacienda Market, was relocated in 1973 during pavement expansion. The flower-bedecked memorial, located on Carmel Valley Road near Via Mallorca, has since become a shrine for passers-by. (Courtesy Pat Hathaway, California Views.)

# Three

# THE RANCHO ERA
# AND EARLY SETTLERS

On January 22, 1828, responding to a request from Alta California governor José Echeandía, Mission padre presidente Vicente Sarría and Padre Ramon Abella wrote the following description of Carmel Valley from the river mouth to about 5 miles inland. "Immediately in front of the Mission one can see that the land contains fields, flocks, the river, hills and plain. There are no neighboring ranchos." Near what would become Rancho San Francisquito, they wrote, "there is no land irrigated. The place is not suitable to summer planting because sufficient heat is lacking in the day. The wind passes through and lessens the night fog, and as early as seven o'clock in the morning the corn and beans have dried up." They described the Carmel River water supply as irregular as a result of swift winter currents and shallow streambeds in summer. One positive comment noted the valley's abundance of redwood, pine, and oak provided a good timber source.

Alta California's affairs were disturbed during the absentee Echeandía administration, operating from San Diego instead of the capital at Monterey. Government officials worried that Mission Carmel had taken all the lands suitable for cultivation, thus keeping out potential settlers. Although the padres' letter seemed to confirm officials' suspicions about the quality of arable acreage, within the next decade and a half, five major grants were bestowed in Carmel Valley. The first, Rancho los Tularcitos (1834), was given to Rafael Gómez, who built the first adobe house in the valley. Rancho San Francisquito (1836) was granted to Catalina Manzanelli de Munras and Rancho Potrero de San Carlos (1837) to Fructuoso del Real. Lázaro Soto received Rancho Cañada de la Segunda in 1839, the same year Rancho los Laureles was granted to José Manuel Boronda. For the next few decades, main rancho enterprises were farming and livestock raising.

Following California's statehood, owners had to prove their property claims. By the 1870s, none of the original grantees held their land, which was sold to settlers. The newcomers introduced modern orchard and farm cultivation, vineyards, irrigation, dairying, and livestock raising.

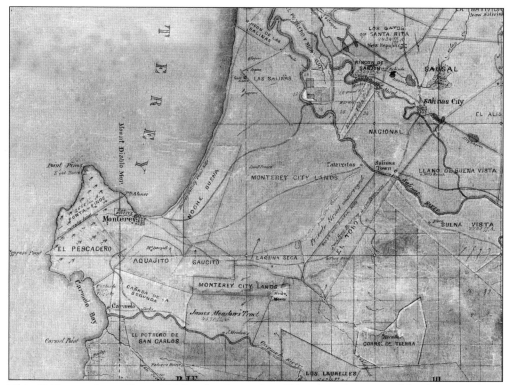

This 1869 map shows Carmel Valley land parcels still bearing the original land grant names. The Carmel River winds into Carmel Valley across the bottom portion of the map. Ranchos Cañada de la Segunda and Potrero de San Carlos appear in the lower left, the James Meadows Tract in the lower middle section, and Rancho Los Laureles at the lower right center. (Courtesy Pat Hathaway, California Views.)

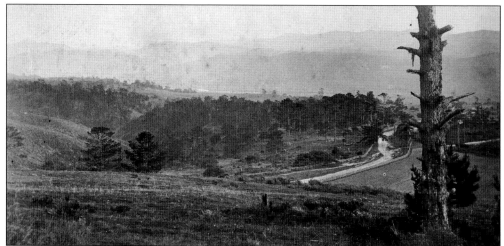

This 1880s scene by photographer Charles Watkins, "Carmel Valley and Mountains, from the Road to the Mission," appears little changed from an 1846 description by reporter Bayard Taylor, who visited the abandoned Mission Carmel. "The beautiful but deserted valley in which it stands is threaded by the Río del Carmel, whose waters once gave unfailing fertility to its now neglected gardens." (Courtesy Colton Hall Museum, City of Monterey.)

The first permanent settlers in Carmel Valley were the José Manuel Boronda family, who moved to their 6,625-acre Rancho los Laureles in 1840. Boronda (1803–1878), shown in this portrait, was an accomplished horseman until a young colt bolted through a forked tree while he was astride, breaking his leg so severely it had to be amputated. (Courtesy Monterey County Historical Society, Inc.)

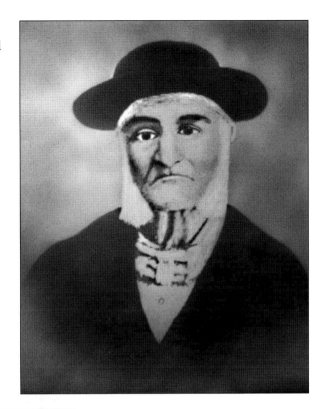

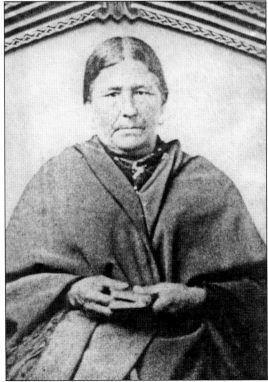

Juana Cota de Boronda (1805–1894) married José Manuel Boronda on May 2, 1821, at San Carlos Cathedral in Monterey. Juana was born in Santa Barbara. Her parents were Manuel Antonio Cota and Maria Gertrudis Romero. She introduced Monterey Jack cheese to Carmel Valley, using a traditional Spanish recipe, and pressed it with a house jack, thus the name "Jack" in the cheese. (Courtesy Monterey Public Library, California History Room Archives.)

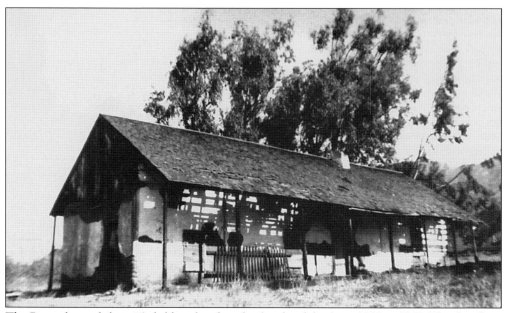

The Borondas and their 15 children lived in the family adobe from 1840 to 1868. The dirt-floor home, which originally had three rooms and a thatched roof, was later expanded. The kitchen was located separately. The family farmed and raised cattle and horses. Later owners housed employees in the home; then it became a cow shed. This 1930s George Seideneck photograph shows the home fallen into ruin. (Courtesy Carmel Valley Historical Society.)

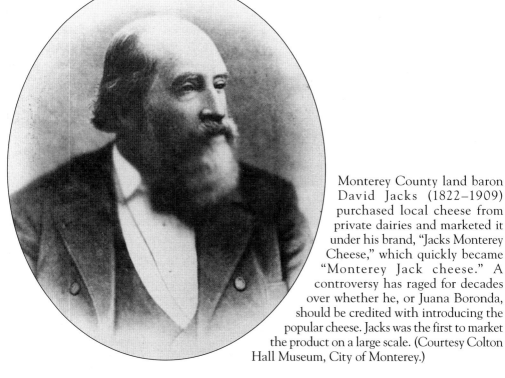

Monterey County land baron David Jacks (1822–1909) purchased local cheese from private dairies and marketed it under his brand, "Jacks Monterey Cheese," which quickly became "Monterey Jack cheese." A controversy has raged for decades over whether he, or Juana Boronda, should be credited with introducing the popular cheese. Jacks was the first to market the product on a large scale. (Courtesy Colton Hall Museum, City of Monterey.)

Following statehood, Mexican land grant holders in California were forced to either prove their claims or lose their property. In 1853, José Manuel Boronda applied for a U.S. patent for Rancho los Laureles. Ownership was granted in 1866 when Pres. Andrew Johnson signed the documents. Monterey *alcalde* Walter Colton, pictured, figured in the initial process when he testified on the Borondas' behalf. (Courtesy Colton Hall Museum, City of Monterey.)

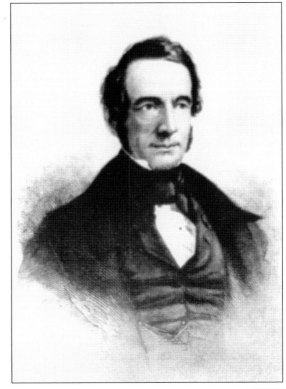

After a succession of owners, George Sims purchased the Boronda adobe in 1947. He restored the structure and grounds and lived on the property until 1960. The home continues in private hands. This late-1940s photograph shows the adobe's restored second story, which was added while the Borondas still lived in the home. (Photograph by George Seideneck; courtesy Carmel Valley Historical Society.)

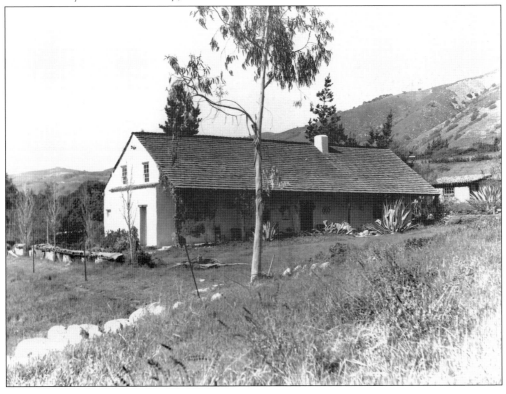

José Antonio "Chino" Boronda (1858–c. 1954), left, was the son of the Borondas' eldest son, Juan de Mata Boronda, and Juana Romero. Chino worked in Carmel Valley and Monterey until 1900, when he moved to Bradley to operate a saloon. He poses around 1880 with Adolfo Sanchez (center), husband of Nellie Van de Grift Sanchez, and Mike Noon, the Monterey wharf master, marshal, and whaler. (Courtesy Monterey Public Library, California History Room Archives.)

In 1837, English seaman James Meadows (1817–1902) jumped ship at Monterey. In 1842, he married Loretta Onesimo de Peralta, daughter of Mission Indian Juan Onesimo and widow of Domingo Peralta. He took over and managed her 4,592 acres in Carmel Valley, renamed the Meadows Tract, located between Rancho los Laureles and Cañada de la Segunda. The Meadowses had four sons and a daughter. (Courtesy Monterey Public Library, California History Room Archives.)

Isabel Meadows (1846–1939) appears as a young woman in this 1860s ambrotype photograph. The daughter of James and Loretta Meadows, she was born in Carmel Valley on July 7, 1846, the same day Commodore John Drake Sloat raised the American flag over the Monterey Custom House. (Courtesy Monterey Public Library, California History Room Archives.)

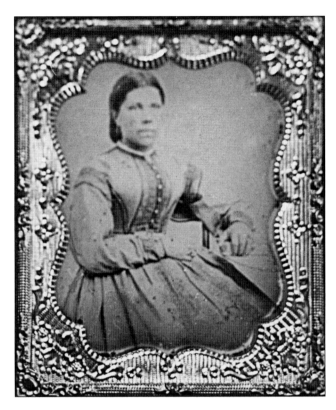

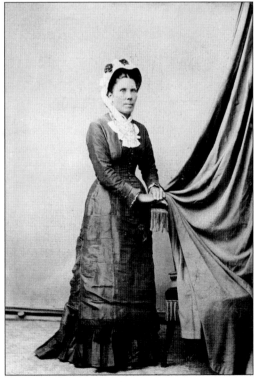

An adult Isabel Meadows poses for a c. 1900 portrait. She grew up in her parents' home in Carmel Valley. The Meadows family was known for their generosity and extended hospitality to both settlers and Native Americans. Isabel later moved to Monterey, where she lived until the 1920s. (Courtesy Monterey Public Library, California History Room Archives.)

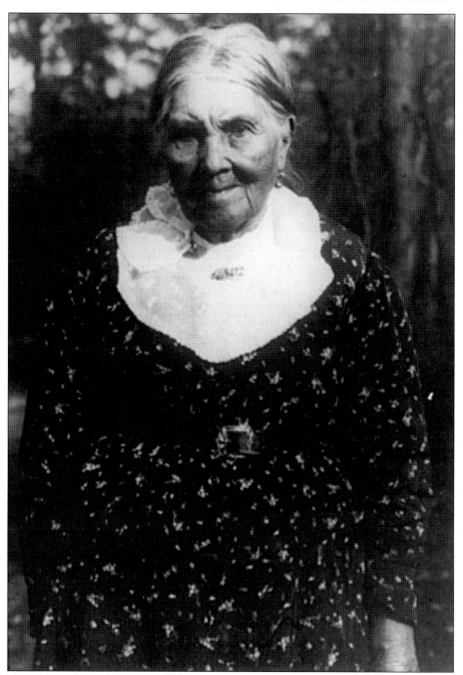

This photograph of Isabel Meadows dates from the 1930s when she was in her 80s. Her recollections of mission life during her grandfather Juan Onesimo's time, as related by her mother, Loretta Onesimo Peralta Meadows, served as a foundation for the novel *Cathedral in the Sun*, by Anne Fisher. Isabel learned to speak the native Rumsen language from her mother. At age 87, she traveled to Washington, D.C., to assist Prof. John Peabody Harrington of the Smithsonian Institution with his research on Rumsen life, language, and culture. She died in the nation's capital at age 93. (Courtesy Monterey Public Library, California History Room Archives.)

Pioneer John Martin (1827–1893) was the son of Carmel pioneers William and Agnes Martin. In 1859, he purchased acreage near the mouth of Carmel Valley. One of two small adobe buildings near today's Mission Carmel became the Martin homestead. Now called Mission Ranch, the resort property was purchased in 1991 by actor-producer Clint Eastwood. (Courtesy Marcia DeVoe Collection.)

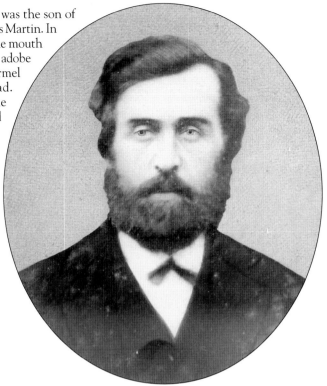

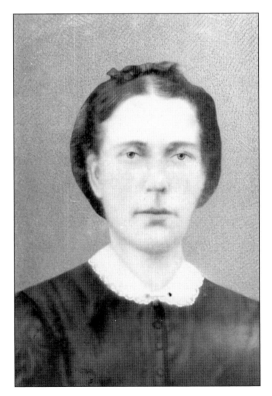

Elizabeth Hislop Stewart Martin (1840–1916), shown in this early portrait, was a widow with three sons, John, Joseph, and Andrew. She married John Martin in 1871 while he was visiting Canada. The couple had seven more children, raising them at the Martin ranch and dairy, located just outside of today's Carmel. It was bounded by Santa Lucia Avenue, Hatton Fields, and the Carmel River. (Courtesy Marcia DeVoe Collection.)

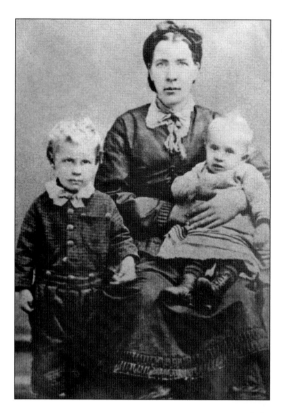

Elizabeth Stewart Martin poses with two of her sons: Robert, in her lap, and William, standing. Elizabeth and her second husband, John Martin, also had sons James, Thomas (who died in infancy), Carmel, and Roy and a daughter, Isabel. (Marcia DeVoe Collection; courtesy Harrison Memorial Library.)

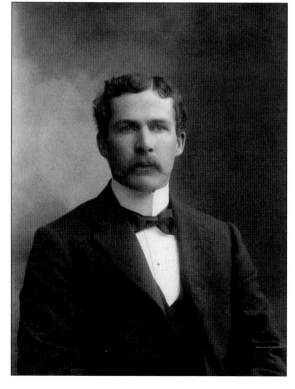

A third-generation member of the Martin family to live in Carmel Valley, William E. Martin (1873–1959) was the son of John and Elizabeth Martin. His grandparents, pioneers William and Agnes Martin, had emigrated from Canada in 1856, traveling through the Isthmus of Panama to settle at Martin's Canyon, 3 miles up the Carmel Valley. (Marcia DeVoe Collection; courtesy Harrison Memorial Library.)

Anna Mary Hatton, shown here as a child in the 1870s, spent part of her youth at Los Laureles Ranch, where her father managed the dairy operation. Her parents were Carmel Valley pioneers William and Kate Hatton. (Marcia DeVoe Collection; courtesy Harrison Memorial Library.)

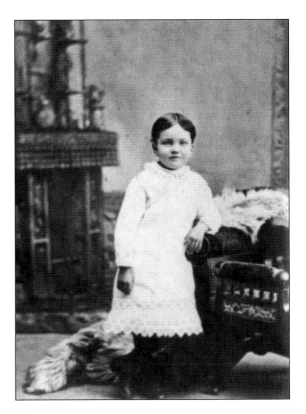

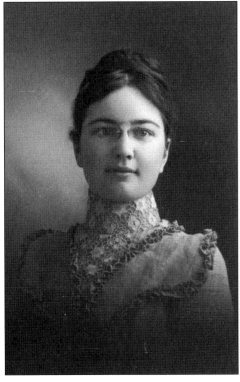

Anna Hatton Martin poses in this portrait taken during her 20s. When she married William E. Martin, two pioneering Carmel Valley families were united. (Marcia DeVoe Collection; courtesy Harrison Memorial Library.)

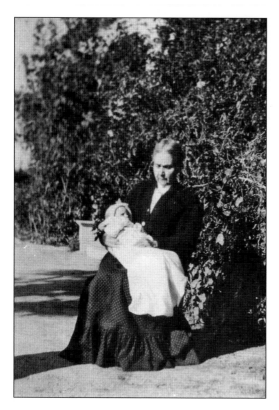

Seated in a flower garden, Kate Harney Hatton holds her great-grandson, Hatton Martin, in this 1908 family photograph. (Marcia DeVoe Collection; courtesy Carmel Valley Historical Society.)

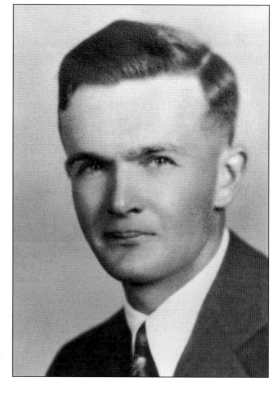

Hatton John Martin (1908–1984), shown in a formal pose, was the son of William Martin and Anna Hatton Martin. He was named for his pioneering grandfathers, John Martin and William Hatton. He attended the Carmelo School in Carmel Valley with members of the Onesimo, Vasquez, Ollason, Meadows, and Wolter families. (Marcia DeVoe Collection; courtesy Harrison Memorial Library.)

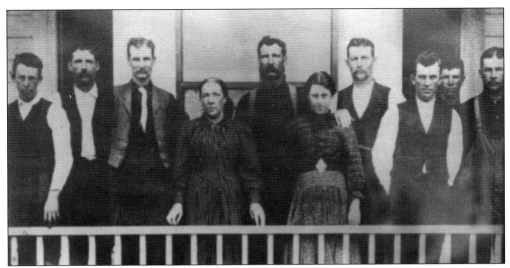

A group of Martins and Stewarts pose for this 1895 front porch photograph. From left to right are Roy Martin, John Stewart, Andrew Stewart, Mrs. John (Elizabeth) Stewart Martin (mother), Joe Stewart, Isabel Martin, Jim Martin, Robert Martin, Carmel Martin, and Will Martin. (Marcia DeVoe Collection; courtesy Harrison Memorial Library.)

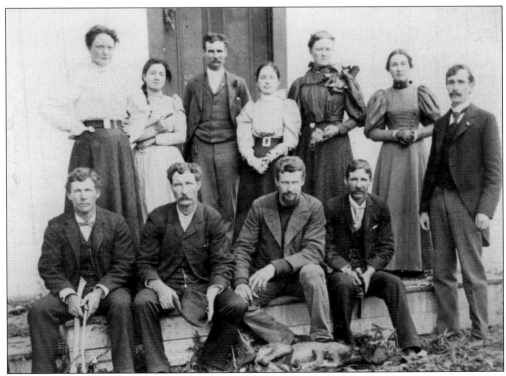

Carmel Valley pioneer descendants gather on a happy occasion in this c. 1900 photograph. Shown are (first row) Will Martin, Joe Stewart, Ted Berwick, and John Stewart; (second row) Ella Berwick, Sarah Hatton, Andrew Stewart, Anna Hatton, Mable Berwick, Harriet Hatton, and G. Kelley. (Marcia DeVoe Collection; courtesy Harrison Memorial Library.)

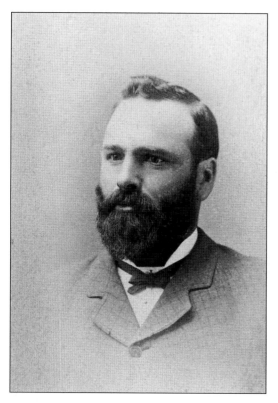

Irish-born William Hatton (1849–1894) arrived in California in 1870, at first working in Salinas before moving to the mouth of the Carmel River. Later employed as manager of the Pacific Improvement Company's Del Monte Dairy at Rancho los Laureles, Hatton modernized the dairy operation, adding Durham cattle to the Holsteins, increasing both the stock breed and the milk butterfat content. (Marcia DeVoe Collection; courtesy Carmel Valley Historical Society.)

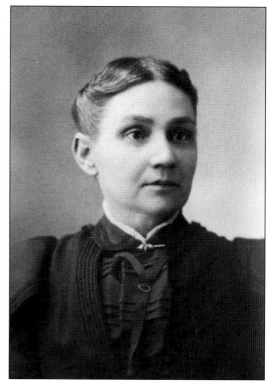

South Carolina native Kate Harney Hatton (1851–1922) raised seven children: Anna, Harriet, Sarah, Edward, William Jr., Frank, and Howard. A hard worker, Kate fed hired hands and joined the regular butchering and harvesting on the family ranch. She was kind to the local Native Americans, often giving them work and money. The Hatton neighbors were the Martins, Snivelys, Meadows, and Berwicks. (Marcia DeVoe Collection; courtesy Harrison Memorial Library.)

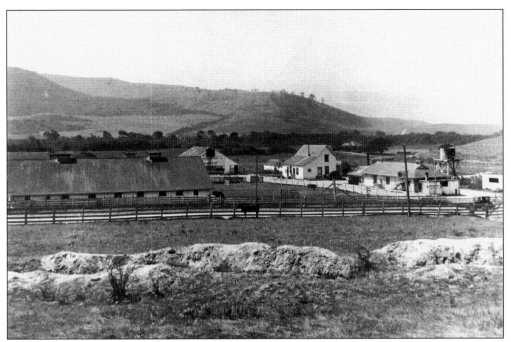

The Hattons purchased Rancho Cañada de la Segunda, near the mouth of the Carmel River, from Dominga Doni de Atherton, Gertrude Atherton's mother-in-law. While managing Rancho los Laureles, William Hatton also operated his own dairy business. The Hatton Lower Dairy, seen here, was located at Highway 1 and Carmel Valley Road, site of the present-day Barnyard Shopping Center. (Marcia DeVoe Collection; courtesy Carmel Valley Historical Society.)

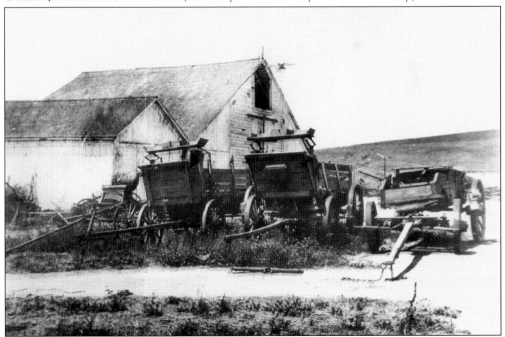

A cluster of wagons sits ready for the next loading in front of a barn at the Hatton Lower Dairy. (Marcia DeVoe Collection; courtesy Carmel Valley Historical Society.)

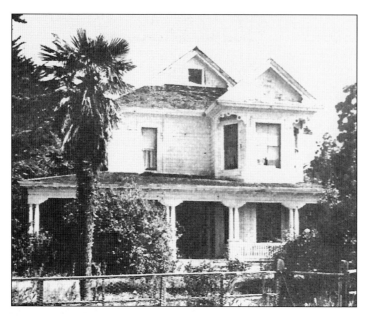

In 1894, the Hattons built an 18-room Victorian on a rise overlooking the valley mouth, located at the present Carmel Knolls subdivision. William died before the home was completed. Kate Hatton continued to run the family dairy with the help of her brother, John Harney. In later years, the unoccupied home was repeatedly vandalized. In the early 1960s, it became a practice burn for local firemen. (Marcia DeVoe Collection; courtesy Carmel Valley Historical Society.)

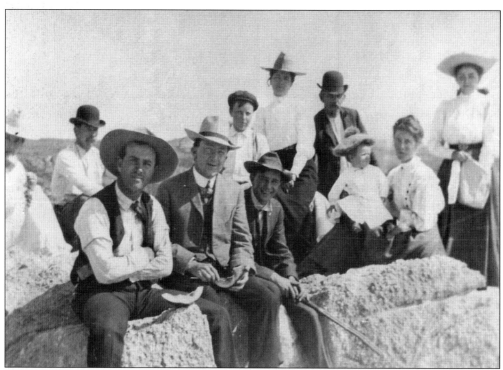

The Hattons and Martins gather for a group shot during a picnic in 1909. Shown from left to right are (first row) Ed Hatton, unidentified, Frank Hatton, Hatton Martin (child), Ida Hatton, and Eliza Vasquez Harney; (second row) Harriet Hatton, Will Martin, Howard Hatton, Anna Martin, and John Harney. (Marcia DeVoe Collection; courtesy Carmel Valley Historical Society.)

The niece of Tiburcio Vásquez, Luciguela Vásquez (1859–1918), who was a granddaughter of José Manuel and Juana Boronda, poses in 1875 at age 16 garbed in a lovely gown for her formal portrait. Luciguela later married Luis Wolter (1841–1926), the son of Capt. Charles Luis Wolter. The couple purchased acreage in Carmel Valley, where their 14 children were born. (Courtesy Russel and Karen Wolter.)

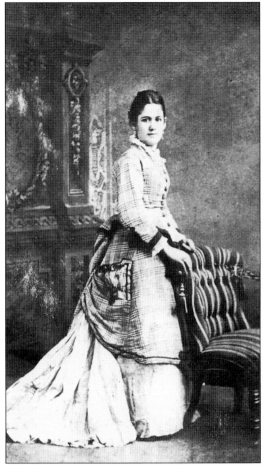

The Luis Wolter family of Carmel Valley poses for the photographer in this c. 1887 sitting. Pictured from left to right are Arturo (son), Luis (father), Lucretia (daughter), Luciguela (mother) with baby Agnes on her lap, and daughters Josephine, Adelina, and Florence. The couple had eight more children. (Courtesy Russel and Karen Wolter.)

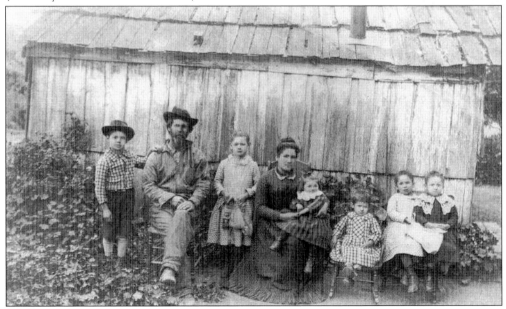

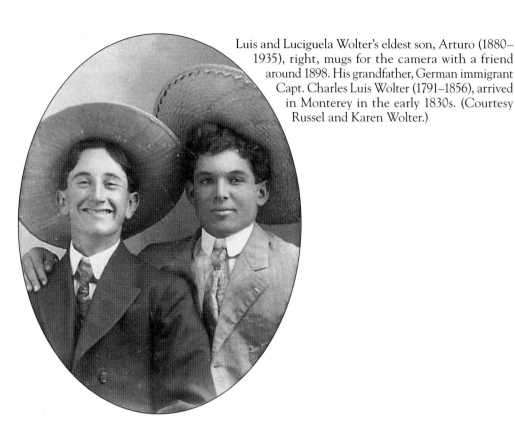

Luis and Luciguela Wolter's eldest son, Arturo (1880–1935), right, mugs for the camera with a friend around 1898. His grandfather, German immigrant Capt. Charles Luis Wolter (1791–1856), arrived in Monterey in the early 1830s. (Courtesy Russel and Karen Wolter.)

An older Luciguela Vásquez Wolter (left) appears in this *c.* 1920 garden scene with her husband, Luis Wolter, and sister-in-law Carrie Whitcomb Wolter (1864–1921), wife of Luis's brother Joseph A. Wolter (1854–1905). Joseph was Monterey's town marshal for 18 years and also served as Monterey's tax collector in 1889. (Courtesy Russel and Karen Wolter.)

Born in London, Edward Berwick (1843–1934) arrived in California in 1865, settling in Carmel Valley in 1869. With help from a Chinese crew, he planted the first commercial pear orchard in Carmel Valley and successfully cultivated and marketed walnuts, apples, vegetables, and strawberries. An accomplished scholar, Berwick taught at the Carmelo School, the valley's first schoolhouse. (Courtesy Monterey Public Library, California History Room Archives.)

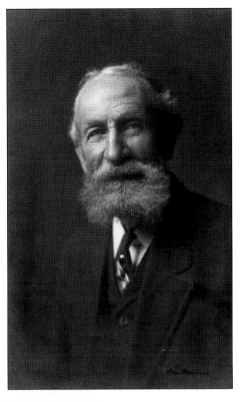

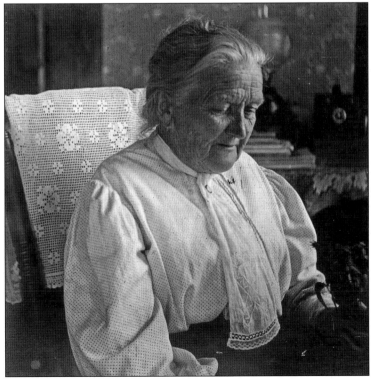

Isabella Richardson Berwick, born in England in 1833, traveled to California in 1867 to marry her fiancé, Edward Berwick. At first they lived near King City, where Edward owned a cattle ranch. After finding the remote life a lonely one, Isabella suggested the pair move to Carmel Valley. They purchased 120 acres of the Meadows Tract near Robinson Canyon Road. (Courtesy Monterey Public Library, California History Room Archives.)

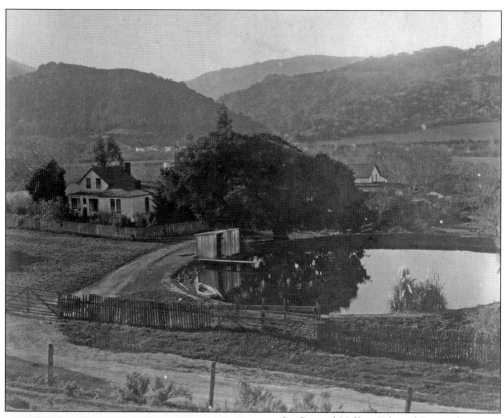

In Carmel Valley, Edward Berwick launched the beginning of a successful industry for local orchardists. The Berwick ranch house, in this 1906 scene, included a pool and barns. Although they later moved to Pacific Grove, Edward commuted to Carmel Valley to manage the acreage. (Courtesy Monterey Public Library, California History Room Archives.)

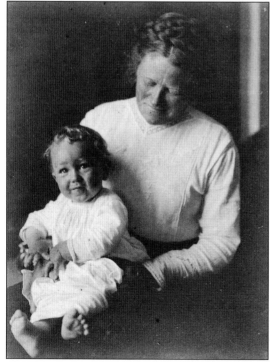

Mabel Berwick Rhodes, youngest daughter of Edward and Isabella Berwick, poses with her son and first child, Edward Berwick Rhodes. She married Frederick Rhodes in 1912, and the pair had five children. (Courtesy Monterey Public Library, California History Room Archives.)

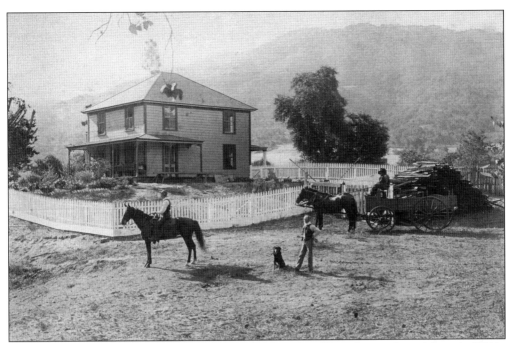

Family members pose around 1885 in front of the Snively-Ollason house. Daniel Snively (1841–1918) took over the ranch operations following the death of his brother, Richard Collier Snively (1839–1896). Snively's Ridge, overlooking Garland Ranch Regional Park, was named for Richard, a successful Carmel Valley dairyman and fruit farmer. The ranch area stretched between Robinson Canyon Road and Carmel Valley Ranch Resort. (Courtesy Monterey Public Library, California History Room Archives.)

This sweeping Carmel Valley view looks toward the southeast, showing Selfridge Lane on the left and the future home of Carmel Valley Ranch (the former Snively-Ollason ranch) on the right. The 1958 scene portrays recently mowed farm fields (lower right) and a pastoral valley looking much as it appeared during the settler and agricultural era. (Photograph by George Smith; courtesy Monterey Public Library, California History Room Archives, Harbick Collection.)

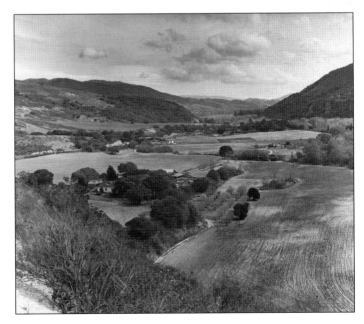

Mary Boice Ollason King Snively (1858–1948) poses for the camera in a Carmel Valley garden. Twice widowed, she first married Sinclair Ollason (1844–1894), a dairy partner with William Hatton. They had three children, Katherine, Wallace, and Stanley Ollason. She married Daniel Snively in 1909 and later gave son Stanley the Snively ranch. The Snivelys were neighbors of the Berwick family. (Courtesy Russel and Karen Wolter.)

Mildred Ollason, shown here in 1918 at about age 10, was the elder daughter of Stanley Ollason (1882–1952). She was raised on the Snively ranch and attended the Carmelo School. (Courtesy Russel and Karen Wolter.)

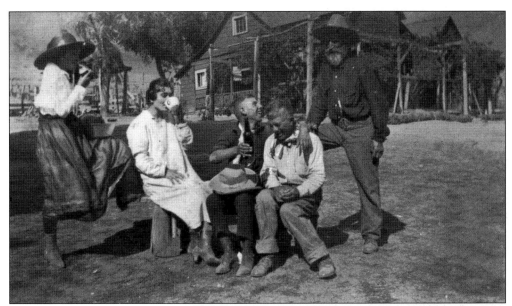

Members of the Piazzoni family relax at their Upper Carmel Valley ranch about 1925. Helen (seated) and Luigi (far right) pose with a sister and neighboring ranchers. (Photograph by Jean Cordero; courtesy Monterey Public Library, California History Room Archives.)

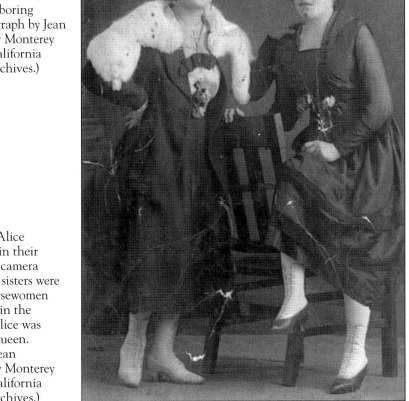

Helen (left) and Alice Piazzoni, dressed in their best, pose for the camera about 1920. Both sisters were accomplished horsewomen who participated in the Salinas Rodeo. Alice was an early Rodeo Queen. (Photograph by Jean Cordero; courtesy Monterey Public Library, California History Room Archives.)

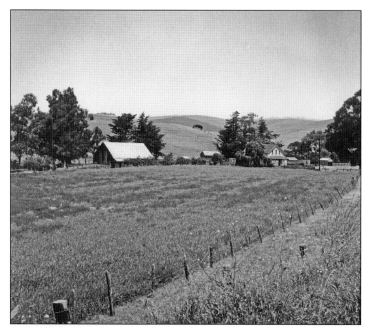

The 1881 *History of Monterey County* noted, "A few miles back of Monterey lies the Carmel Valley, dotted with farm-houses and dairy buildings. The planting of vines and almonds has been successfully tried here; while peaches, apricots, pears, nectarines, cherries and strawberries thrive." This 1950s scene portrays a similar cluster of farm buildings set in a still-rural Carmel Valley. (Courtesy Monterey Public Library, California History Room Archives.)

This 1949 scene echoes the same 1881 history volume and described Carmel Valley as "a region of fine large oak openings, splendid parks of beauty, of lovely small prairie scenes green with rich native grasses, of more beautiful views of fields of grain, of meadows, pasturage, and orchards, with ornamental yards and gardens around pleasant dwellings." (Courtesy Monterey Public Library, California History Room Archives, Harbick Collection.)

# *Four*

# WORKING ON THE LAND

In his 1850 volume, *Three Years in California*, the Reverend Walter Colton praised Carmel Valley's natural resources: "Through its ample lands flows a beautiful stream of water, which every governor of the country, for the last thirty years, has purposed conducting to the metropolis. Its gardens supply the vegetable market of Monterey. Its pears are extremely rich in flavor. In its soil were raised in 1826, the first potatoes cultivated in California. So little did the presiding padre think of this strange vegetable, he allowed the Indians to raise and sell them to the whalers that visited Monterey."

An 1881 History of Monterey County described the valley's major products as "beef, butter, cheese, potatoes, pork, whale oil and dried fish." Dairy, livestock, and grain were also large industries in the early settler period, with farm produce including corn, squash, tomatoes, melons, and grapes. The products were sold locally or sent to Monterey for shipment to San Francisco markets.

For decades, Carmel Valley was recognized for its pear orchards, first introduced in 1795 by Padre Lasuén at Mission Carmel. A large pear industry was developed by settlers and their descendants, with 400 pear orchard acres under cultivation by the early 20th century. The successful local enterprise led to the organization, on March 1, 1920, of the Carmel Valley Fruit Growers Association. The major varieties—Comice, Clairgeau, Winter Nellis, Anjou, and Bosc—were harvested in September and October. After picking, the pears were washed, graded, and individually packed in pine boxes. From 90 to 100 refrigerated carloads of the fall and winter varieties went to market each year. The farmer cooperative shipped them via the California Fruit Exchange agency to eastern auction markets, usually New York. Most of the orchards were torn out by the early 1940s after Carmel Valley's pear market went into decline and collapsed.

In recent decades, Carmel Valley's bountiful farm production has given over to organic produce and particularly to wine grape cultivation. Estate boutiques offer wine tasting to visitors who come to savor the newest product growing in the valley's rich soil.

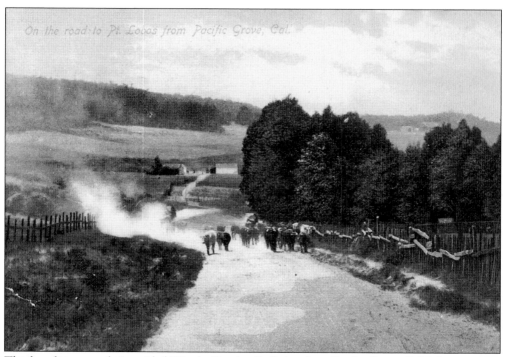

This bucolic postcard view, titled "On the Road to Pt. Lobos from Pacific Grove, Cal.," shows a worn dirt road headed south toward the mouth of Carmel Valley as it appeared around 1902. The same route is followed today by U.S. Highway 1 as it passes the entrance to Carmel Valley Road.

"Patterned hills and dales," photographed in 1958, evokes a Carmel Valley of enfolding hills and endless vistas as described by J. Smeaton Chase, who traveled the California coast on horseback in 1913. Upon seeing Carmel Valley, he wrote of the tranquil hills that rose on either side of the valley, with a peaceful river flowing silently in between. (Photograph by George Seideneck; courtesy Monterey Public Library, California History Room Archives, Harbick Collection.)

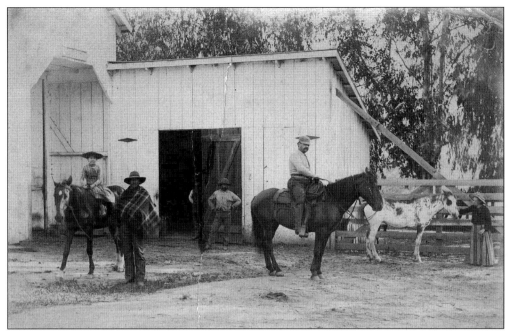

Titled "Frank Douty Starting Back to Camp, June 13, 1889," this scene shows Frank S. Douty (1855–1900), the secretary of the Pacific Improvement Company (center), astride a horse as workers pause at Los Laureles Ranch headquarters. At the time, part of the ranch was being turned into a resort for hunters, fishermen, campers, and day visitors. (Marcia DeVoe Collection; courtesy Harrison Memorial Library.)

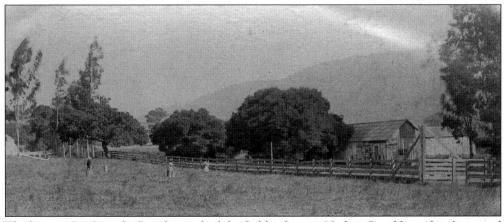

The barns at Los Laureles Ranch were built by Oakland mayor Nathan Spaulding when he owned the ranch from 1874 to 1881. Spaulding grew alfalfa on 1,000 acres of the ranch for cattle feed and brought in modern irrigation to water his fields. The next owners, the Pacific Improvement Company, expanded Spaulding's cattle and dairy operation. (Marcia DeVoe Collection; courtesy Harrison Memorial Library.)

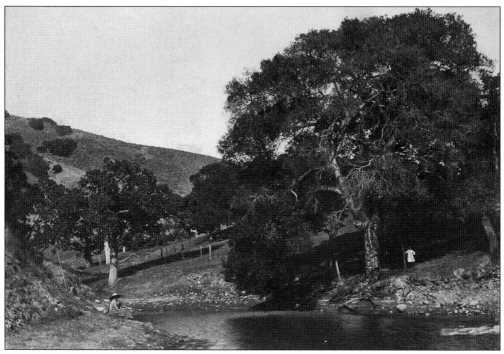

Titled "Reservoir, Los Laureles Ranch with Hatton Girls," this 1889 photograph shows a water storage area on the sprawling ranch. The Hatton daughters were Anna, Harriet, and Sarah, whose father, dairyman William Hatton, was the Pacific Improvement Company's ranch manager. (Marcia DeVoe Collection; courtesy Harrison Memorial Library.)

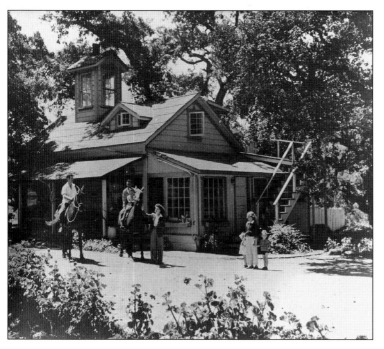

The Del Monte Milk Barn, located in today's Carmel Valley Village, dates to 1890 when William Hatton built an auxiliary dairy, which included the milk barn. The ventilation tower atop the roof allowed fresh milk to cool rapidly. The building in recent years has served as an art gallery and a restaurant. (Photograph by George Seideneck; courtesy Carmel Valley Historical Society.)

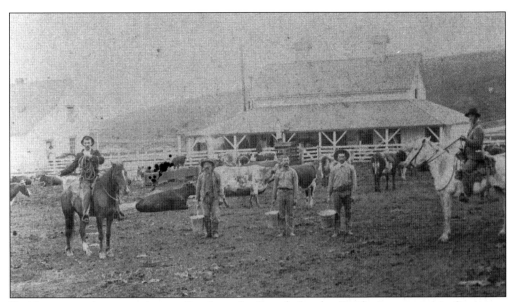

Besides overseeing operations at Los Laureles Ranch for the Pacific Improvement Company, William Hatton owned a dairy at Rancho Cañada de la Segunda at the mouth of Carmel Valley. Here a group of workers in 1890 gets ready to round up the cows for milking. (Marcia DeVoe Collection; courtesy Carmel Valley Historical Society.)

This horse-drawn dairy wagon, shown here around 1890, belonged to the Pacific Improvement Company's dairy at Los Laureles Ranch and hauled supplies into Monterey and Carmel. The ranch brand Del Monte supplied milk and other dairy products to guests of the Del Monte Hotel and commercially marketed Mrs. Boronda's Monterey Jack cheese under the name Del Monte Cheese. (Marcia DeVoe Collection; courtesy Carmel Valley Historical Society.)

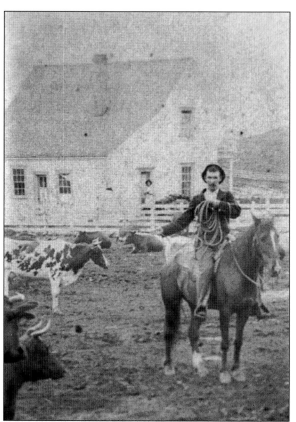

A vaquero poses in front of one of the Hatton barns around 1890 while a Durham cow waits for milking time at the Hatton Lower Dairy ranch. (Marcia DeVoe Collection; courtesy Carmel Valley Historical Society.)

A horse team pulls a grain planter at the Hatton Lower Dairy ranch in 1900. (Marcia DeVoe Collection; courtesy Carmel Valley Historical Society.)

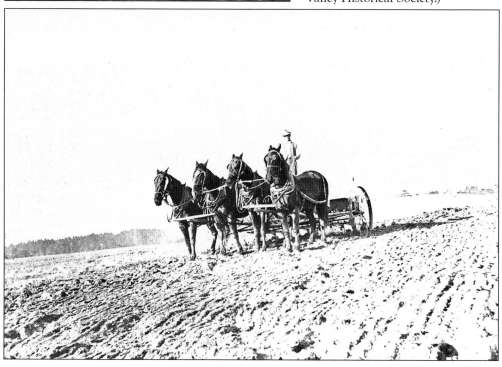

Cattle drives were commonplace along Carmel Valley Road, as in this undated photograph in which a herd is moved to a fresh local pasture. The drive to markets in the Salinas Valley was a two-day trip. (Marcia DeVoe Collection; courtesy Carmel Valley Historical Society.)

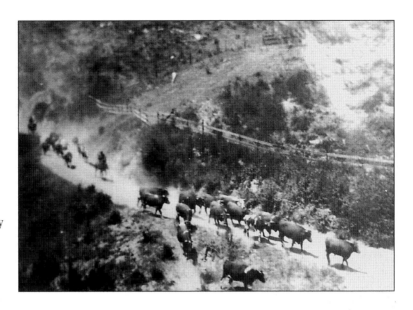

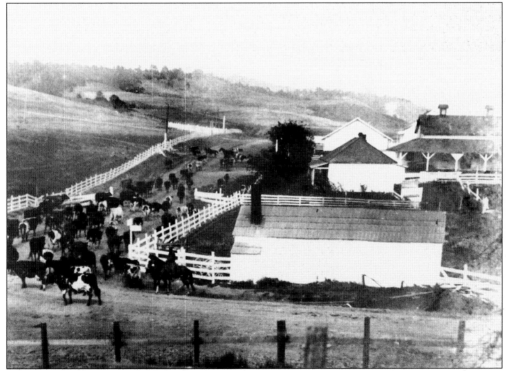

In this 1895 scene, shot at the Hatton Lower Dairy at the mouth of Carmel Valley, a vaquero on horseback (lower left) herds cattle toward the milking barn. (Marcia DeVoe Collection; courtesy Carmel Valley Historical Society.)

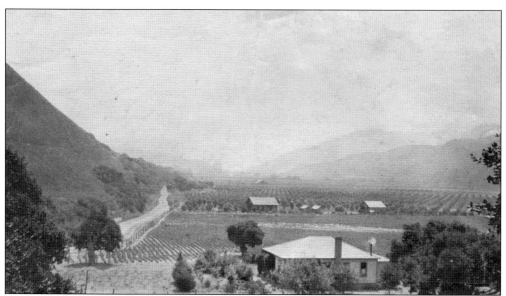

Headed farther up Carmel Valley Road from the Hatton Ranch, Thomas Meadows (1861–1959) lived in the house in the lower forefront, across the road from the home of Andrew Stewart, the son of Elizabeth Stewart Martin and stepson of John Martin. (Courtesy Harrison Memorial Library.)

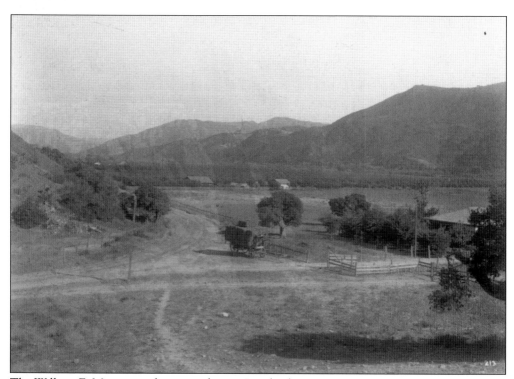

The William E. Martin ranch, pictured in 1917 with a hay wagon out front, was also located near the Hatton ranch. William E. Martin was married to Anna Hatton. (Photograph by L. S. Slevin; courtesy Monterey County Free Library.)

Horse-drawn haying, as pictured at the Ollason Ranch in the 1930s, was an arduous job under the hot sun. Neighbors often assisted, pitching in to help each other in turn during the season. (Courtesy Russel and Karen Wolter.)

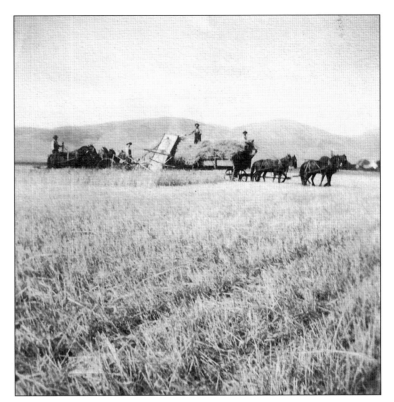

The barn belonging to Luis Wolter (1841–1926) was kept ready to hold the season's hay supply for the family-owned stock. According to Joe Hitchcock's memoirs, "In those days work was hard for all and the working day was a long one. By the time the evening chores were done, the men were ready for sleep, especially during plowing and haying season." (Courtesy Russel and Karen Wolter.)

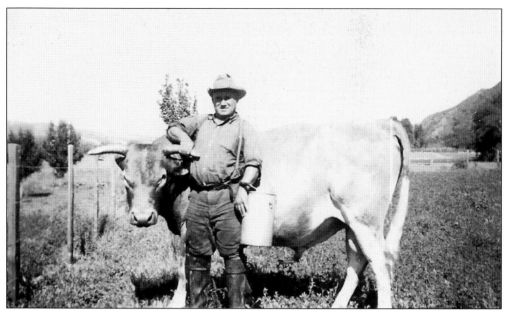

Cattle raising produced a winner for Luis Wolter's son, Luis Federico Wolter (1894–1957), seen here on the family ranch in 1937 with his Grand Champion bull. (Courtesy Russel and Karen Wolter.)

Luis Federico Wolter met his future wife, Martha Winslow, in San Francisco. The couple poses in the early 1950s at their business, Wolter's Hacienda Market (now Hacienda Hay and Feed), located at Valley Hills Shopping Center. The Wolter Market was especially popular for its annual pumpkin harvest and display, a Carmel Valley tradition that continues today. (Courtesy Russel and Karen Wolter.)

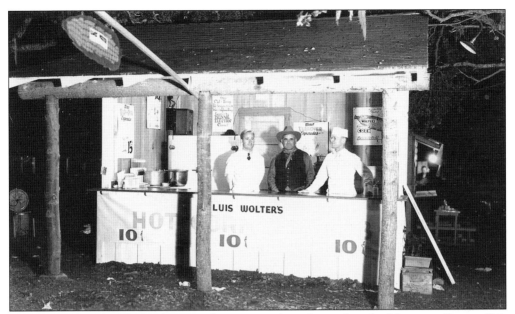

Luis Federico Wolter (center) operated a corn-on-the-cob stand at the Monterey County Fair with the two unidentified workers pictured here in the 1940s. He grew fruits and vegetables and drove a sales route in town. When the family first sold produce in Carmel Valley, sons Luis and Russel had to sleep in the stand at night to guard the food until Wolter's Hacienda Market was enclosed. (Courtesy Russel and Karen Wolter.)

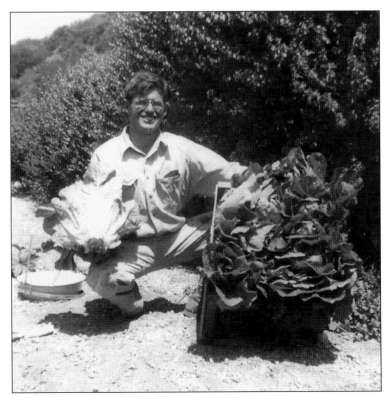

A smiling Russel Wolter around 1950 shows off lush heads of lettuce grown at the family's Carmel Valley farm. (Courtesy Russel and Karen Wolter.)

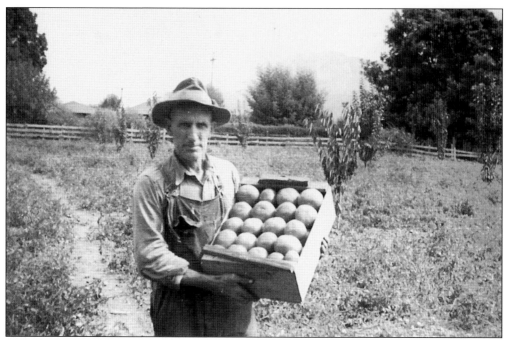

D. Porter Carder of Carmel Valley proudly displays a box of his ranch-grown tomatoes in this 1937 scene. Produce and truck farms proliferated along the wider portions of the valley during the era. (Courtesy Russel and Karen Wolter.)

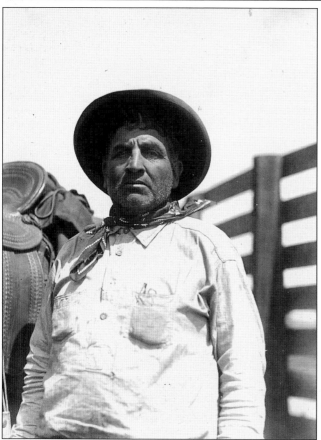

Buffalo Torres, a Doud Ranch worker, takes a break while roping calves in the late 1930s. The Doud Ranch was located near today's Carmel Valley Manor. (Courtesy Russel and Karen Wolter.)

Russell Kendall, a cowboy, poses
during a sunny Carmel Valley
day in this late-1930s photograph.
(Courtesy Russel and Karen Wolter.)

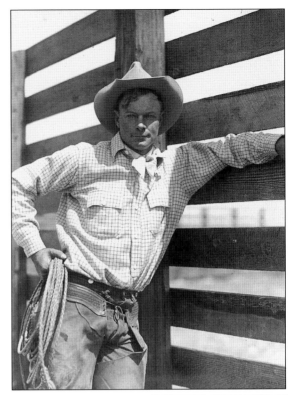

Gus Wolter (1888–1937), left, and
Stanley Ollason (1883–1952), kneeling
center, corral and rope a cow on a
Carmel Valley workday in the 1930s.
(Courtesy Russel and Karen Wolter.)

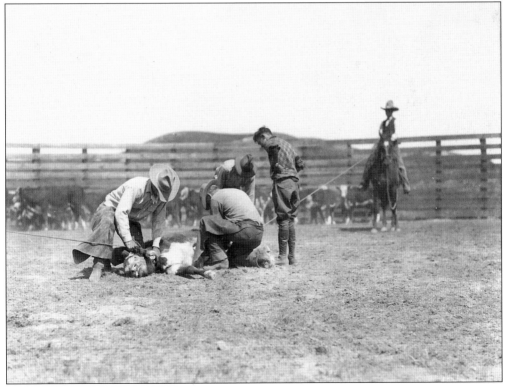

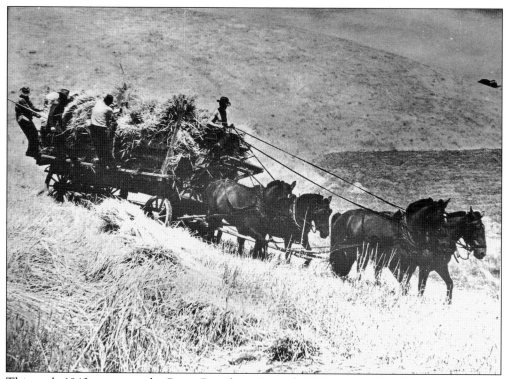

This early-1940s scene at the Berta Ranch in Carmel Valley shows Patrick Berta driving a wagonload of harvested grain to the separator. Isidore Berta (left), Jim Wolter (center), and an unidentified worker help out. The big wagon often required four horses, wheelers Belle and Queenie and leaders Chub and Dolly. The Bertas often bred their own large work horses. (Photograph by George Seideneck; courtesy Carmel Valley Historical Society.)

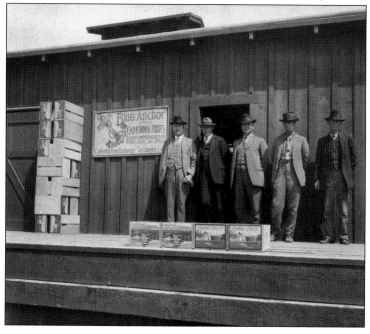

The Board of Directors of the Carmel Valley Fruit Growers Association stands on the receiving platform of the pear packinghouse in Monterey in this late-1920s photograph. Shown from left to right are J. H. Stewart, B. H. Schulte, Stanley Ollason, and Roy Martin, all Carmel Valley Growers, with C. L. Ingalls, a pear grower from Corral de Tierra. (Courtesy Monterey Public Library, California History Room Archives.)

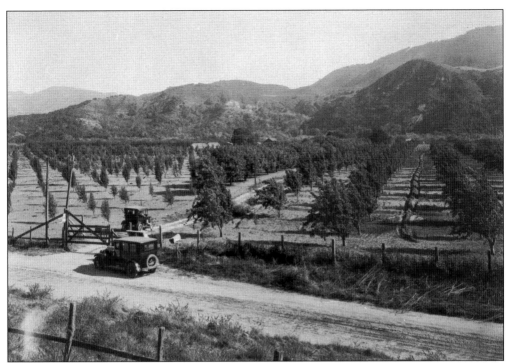

This 1920s scene shows automobiles entering Schulte Road from Carmel Valley Road. The orchard to the right of Schulte Road belonged to the Roy Martin family. The Schulte family orchard is located to the left of the road. The fence and gate were installed to keep out strays from the cattle drives along Carmel Valley Road. (Courtesy Monterey Public Library, California History Room Archives.)

This pastoral 1920s scene looks north from the intersection of Carmel Valley and Schulte Roads. The pear orchards, considered an especially beautiful sight when blooming in spring, were located in the area between the present Quail Lodge and Carmel Valley Ranch. (Courtesy Monterey Public Library, California History Room Archives.)

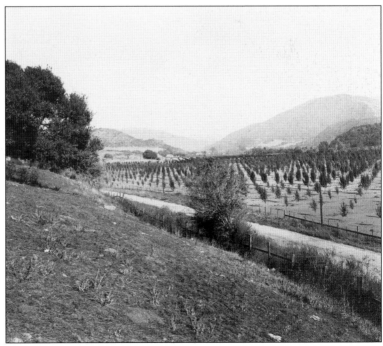

Chinese immigrants contributed to the workforce in Carmel Valley, planting orchards, tending crops, and working on roads. Here Sam, the Chinese cook at the Hatton Lower Dairy, rings the dinner gong on May 25, 1928, to call the ranch hands in for supper. (Courtesy Monterey County Free Libraries.)

Resting at day's end, a farmer pauses at dusk with his horse and plow to contemplate the serene Carmel Valley landscape in this undated photograph. (Courtesy Carmel Valley Historical Society, Julie Risdon Collection.)

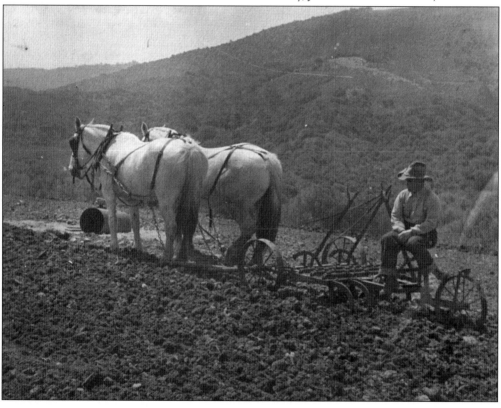

*Five*

# HOW WE LIVED

In May 1861, surveyor William H. Brewer visited Judge Fletcher M. Haight, who briefly owned part of Rancho Cañada de la Segunda. Haight's son, Henry, became governor of California (1867–1871), and Haight Street in San Francisco was named for him. Following dinner, Brewer wrote, "We climbed a hill just above, and had a pretty view of the Carmelo Valley, the sea beyond and the mountains to the south. He has a fine ranch, keeps about twelve hundred sheep. We rode home by twilight. One dared not wait later for fear of grizzlies."

Watching out for grizzlies was a reality, but for residents, life in Carmel Valley was more. Parents sought education for their children, neighbors helped one another, and when the workweek ended, the socializing began. Old-timer Joe Hitchcock, writing in his 1950s *Carmel Valley News* columns, left poignant details of life in the valley where he grew up. It was a transitional time for the young lad, who saw the era of horse-drawn work wagons turn into the age of gasoline-run tractors. He wrote of his school days, of his family's ties with descendants of early valley settlers, of life at Los Laureles Ranch where he spent his childhood, and of the social occasions where folks brought potluck, danced through the night, and enjoyed the local camaraderie.

Back before there was a Carmel Valley Village, there was Robles del Rio, the first subdivision in Carmel Valley, built in the 1920s. In 1939, the realty office became a general store known as Rosie's Cracker Barrel. Social life began to shift in the 1940s because Carmel Valley had been "discovered." No longer just a summer spot, it became a place where a family could sink roots. The kids not only attended school together but also rode horseback, caught fish, hunted, and swam in the river together.

The grizzlies are gone, but the Valley's ambience remains: oak-dotted hillsides, looming mountains, the running river, and the nearby sea, so poignantly captured by William Brewer, who came to visit and left a memory.

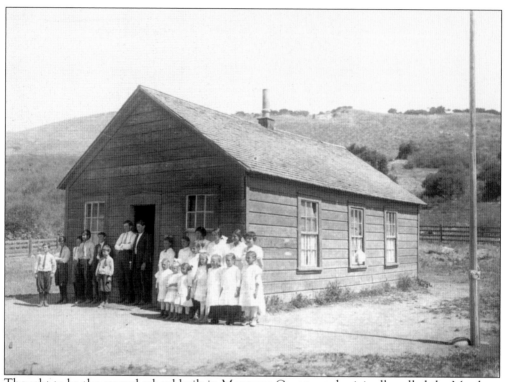

Thought to be the second school built in Monterey County and originally called the Meadows School, the Carmelo School was built on land deeded in 1858 by pioneer James Meadows. The first students were from the Wilder, McKenzie, Williams, McClurg, Tomassini, Coleman, Selfridge, Meadows, Wolter, Branson, Martin, and Tice families. Orchardist and scholar Edward Berwick was an early teacher. (Courtesy Monterey County Free Libraries.)

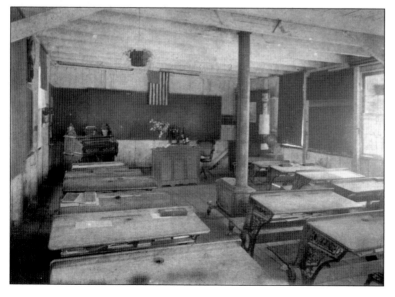

An orderly education in a tidy classroom awaited students attending the one-room Carmelo School. James Meadows made the original double desks from Monterey pine. "Since we had to sit in pairs, it was a real disgrace when a boy had to change his desk and sit with a girl," Joe Hitchcock reminisced about the old school days. (Courtesy Russel and Karen Wolter.)

Carmelo School students, several identified, pose for a class picture: the boy at left is Jack Parker, followed by the Tomassini girls; Howard Meadows (with hat) stands in the rear with a boy identified as "Panocha" at the end. (Courtesy Russel and Karen Wolter.)

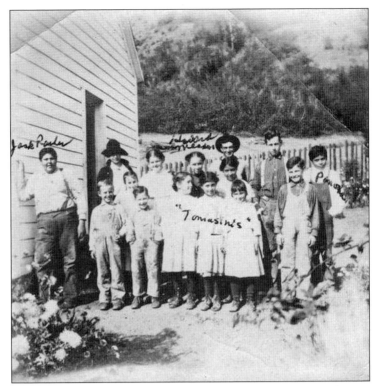

The first Carmelo School was torn down in 1916, and a two-room schoolhouse was built in its place. The building still stands just west of the Mid-Valley Fire Station and across Carmel Valley Road from the present Carmelo School. This June 10, 1920, photograph shows the graduating class. Emily Martin Williams, fourth from left, was the granddaughter of William Hatton and John Martin. (Courtesy Carmel Valley Historical Society.)

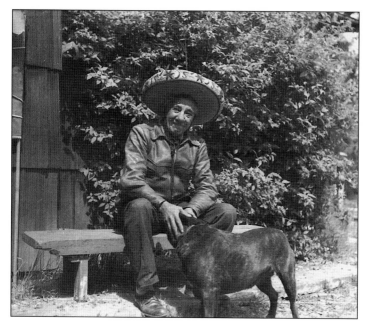

Joe Hitchcock (1881–1969) poses around 1960 with his dog, Pal. While serving in the U.S. Navy, his grandfather Lt. Isaac Hitchcock accompanied Commodore John Drake Sloat in the 1846 seizure of Monterey. Isaac married Madalena Peralta Meadows, the daughter of Loretta Peralta Meadows. Joe was born at Los Laureles Ranch and attended Tularcitos School. His memoirs of early Carmel Valley life have provided lively insight for historians. (Courtesy Carmel Valley Historical Society.)

The second Tularcitos School building appears in this 1932 photograph. The original 1880s Tularcitos School sat at Carmel Valley Road and Laureles Grade, measured 20 by 40 feet, and held 12 double desks. In 1893, a new school was built farther up the valley at the present Stonepine Resort site. Folk singer Joan Baez held non-violence seminars in the building from 1965 to 1969. (Courtesy Monterey County Free Libraries.)

Now a sculpture studio, the white wooden building adjacent to Farm Center at Carmel Valley and Robinson Canyon Roads was built in 1890 as a gathering spot for local farm families. Called the Carmelo Athletic and Social Club, the structure was used for grange, town hall, and 4-H meetings, dances, parties, and suppers. The Stewart, Martin, and Berwick families built the club on donated land. (Courtesy Pat Hathaway, California Views.)

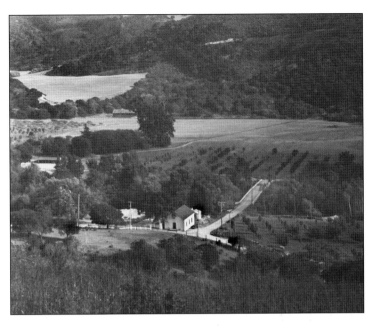

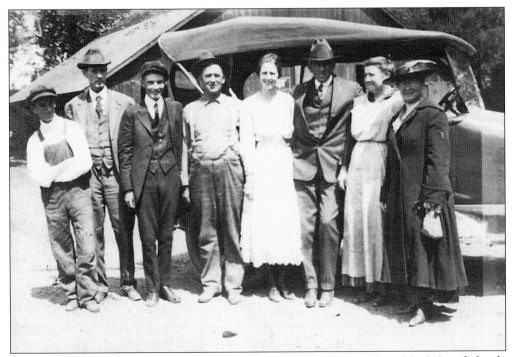

Ready for a favored pastime, Stanley Ollason, fourth from left, poses on June 30, 1918, with family and friends for a leisurely Sunday drive. From left to right are Harry MacDonal, Mr. Thompson, George MacDonald, Stanley Ollason, Imogene Thompson, Bob Stirling, Mrs. Thompson, and Mattie Stirling. (Courtesy Russel and Karen Wolter.)

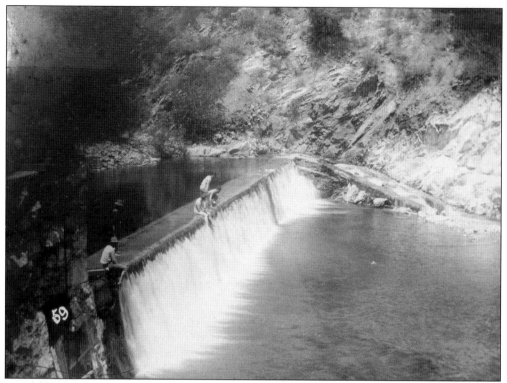

A small dam on the Carmel River was constructed in the 1880s by William Hatton for the Pacific Improvement Company. It completed the 8-mile water channel and small reservoir begun by Oakland mayor Nathan Spaulding in 1876. Here the boys of Troop C, California National Guard, skinny dip during a *c.* 1906 camp break. (Courtesy Kent Seavey, Dr. John Baker Collection.)

The early Carmel River dam was supported by stone walls. Here the ledge makes a convenient fishing and jumping-off spot for Carmel Valley youth around 1890. (Courtesy Monterey County Historical Society, Inc.)

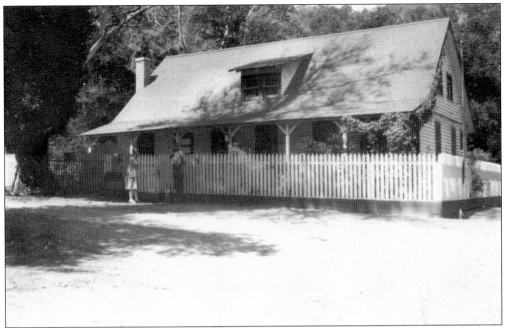

In 1886, John James opened the Jamesburg Post Office in his Upper Carmel Valley home. Mrs. Cynthia James was the first postmistress. After an 1889 flood swept through, the James home, its post office, and stage stop were relocated to a second house (pictured). The Lambert family bought the property in 1920 and continued both the postal service and a county library branch. (Courtesy Monterey County Free Libraries.)

Titled "The Jamesburg Library Staff," this photograph was snapped in 1917. The Monterey County Library branch at the old James/Lambert home was located on the road to Tassajara Springs. Mrs. Eleanor "Nellie" Chew was the library's first custodian. (Courtesy Monterey County Free Libraries.)

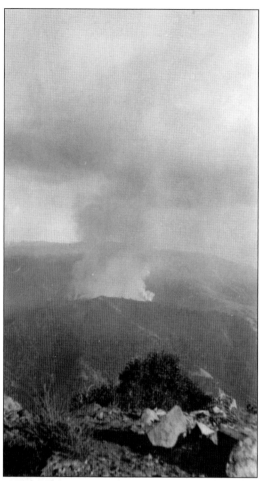

During the dry summer months, the Upper Carmel Valley region has been threatened by an occasional major fire, usually originating in the Ventana Wilderness or the Los Padres National Forest. Blazes have sometimes approached within a few miles of Carmel Valley Village. L. S. Slevin captured this devastating fire at Cone Peak on August 1, 1928. (Courtesy Monterey County Free Libraries.)

Sam Avila heads up a rugged mountain pass to pack in supplies for men fighting the Cone Peak fire in this August 1, 1928, photograph by L. S. Slevin. (Courtesy Monterey County Free Libraries.)

The Chews Ridge Lookout Station was built in Upper Carmel Valley in 1919. It was one of the first fire lookouts in the Los Padres National Forest. The steel tower was added in 1929, the year this photograph was taken. (Courtesy Monterey County Free Libraries.)

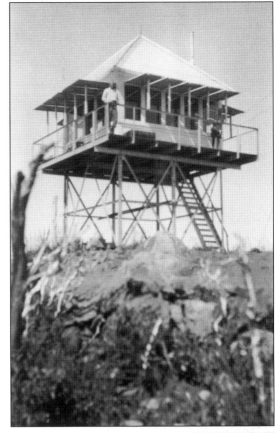

Before the San Clemente dam was completed, floodwaters regularly overflowed the banks of the Carmel River, rendering road passage nearly impossible. Here a horse and wagon ferry grateful passengers across the roadbed on February 11, 1922. Notice the waiting car and driver at right. (Courtesy Monterey County Free Libraries.)

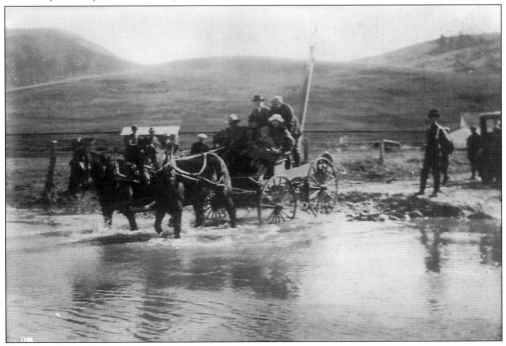

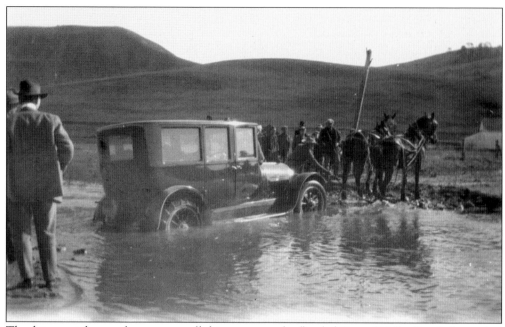

The driver watches as a horse team pulls his car across the flooded Carmel Valley Road after raging river waters cut off passage on February 11, 1922. (Courtesy Monterey County Free Libraries.)

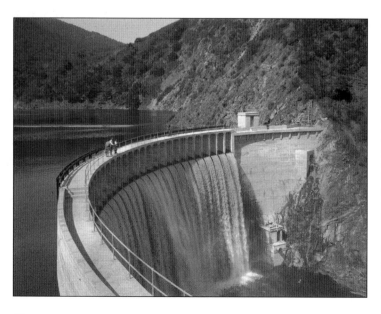

Visitors in this 1924 scene admire the new San Clemente Dam in this photograph titled the "Del Monte Dam." Built in 1921 as an enlargement of the original 1883 dam located on the Carmel River, the concrete-arch reservoir was constructed by the California Water and Telephone Company. (Courtesy Julian P. Graham/Loon Studios and Monterey Public Library, California History Room Archives.)

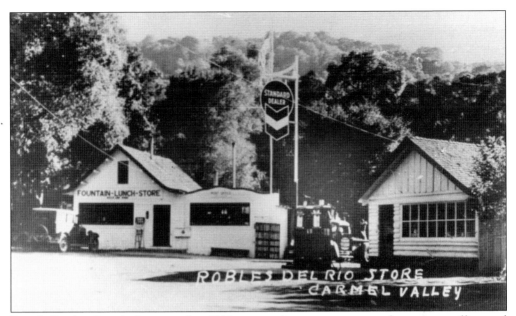

Rosie's Cracker Barrel, shown in this 1940s postcard scene, was a general store, post office, and gas station owned by William I. Henry, known as "Rosie." It was built in 1926 as the Robles del Rio sales office for the Porter-Marquard Realty Company. Rosie turned it into a store in 1939. The structure is located east of today's Carmel Valley Village. (Courtesy Carmel Valley Historical Society.)

Rosie stands at his cash register waiting on two regulars. The store was popular with both summer and year-round residents. For several decades, Rosie's Cracker Barrel was a community gathering spot where parents brought the kids for a popsicle and paused for a beer and a chat with the locals. Saturday night dances were accompanied by jukebox music and occasionally an accordion. (Courtesy Carmel Valley Historical Society.)

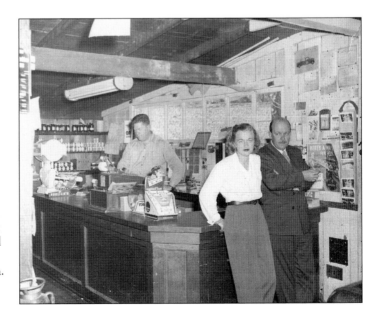

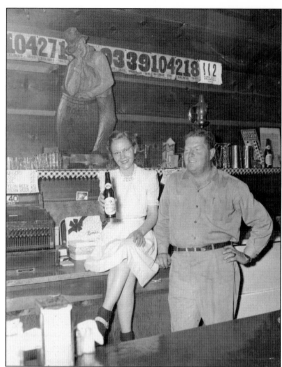

A simple hamburger in Rosie's back barroom included plenty of libations for the regulars who hung out at the popular spot. William I. "Rosie" Henry (1904–1982) is pictured here with a lady friend. The store and bar were open seven days a week. Occasional visitors included Mary Pickford, Bette Davis, Ronald Coleman, Eddie Albert, Arthur Murray, and cartoonist Virgil Partch. (Courtesy Carmel Valley Historical Society.)

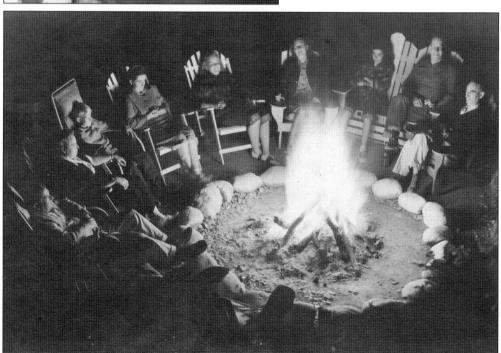

A group of pals relaxes and reminisces around the outdoor fire pit at Rosie's Cracker Barrel on a 1940s summer evening. From left to right are William I. "Rosie" Henry, his sister Evelyn Wallace, Jimmy Smith, Georgia Wallace, Audre Graft Weimer, Rosie's girlfriend Bobbie Smith, Gail Wallace Brown, Mott Hitchcock, and George Wallace. (Courtesy Carmel Valley Historical Society.)

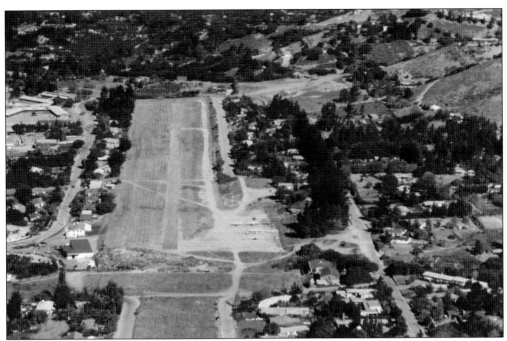

This 1975 aerial view shows a deactivated Carmel Valley Airport bordered by homes, offices, and a school. The strip was built by Byington Ford in 1940 as an airpark fly-in for locals who lived in his newly developed Carmel Valley Village. Although the village developed, the airstrip was closed because of noise and environmental concerns. The airstrip is listed on the California Register of Historical Resources. (Courtesy Carmel Valley Historical Society.)

World War II Civil Defense volunteers Tillie Goold (left) and Evelyn Wallace stand by the government airplane lookout station located at the northern end of the Carmel Valley airstrip. The station's emergency hand-cranked telephone was once misused by a volunteer who was fired after getting drunk and phoning in a false report of German U-boats coming up the Carmel River. (Courtesy Jim Goold.)

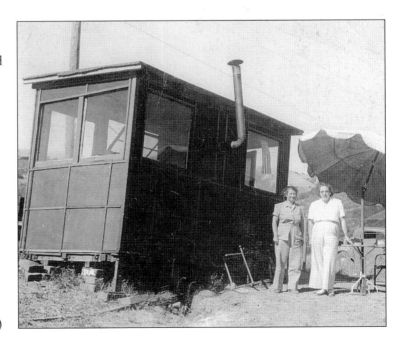

This 1940s strip of retail stores, intended to serve residents who purchased homes near the Carmel Valley airstrip, continues today as one of two small shopping centers in the heart of Carmel Valley Village. (Courtesy Pat Hathaway, California Views.)

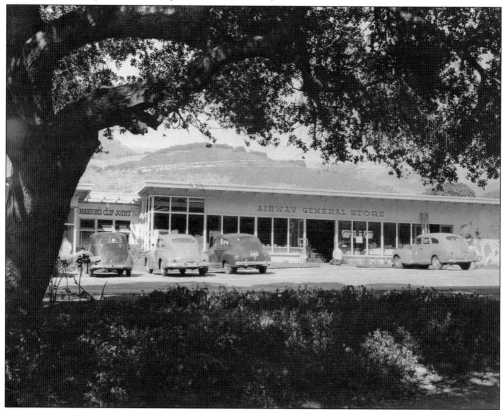

Carrying on the 1940s airpark theme, this section of the original Carmel Valley shopping strip was known as the Airway General Store. Besides the grocery, in recent years, the strip space has added a business service, video shop, liquor store, cafés, boutiques, a beauty shop, and a restaurant. (Barbara Marks Collection; courtesy Carmel Valley Historical Society.)

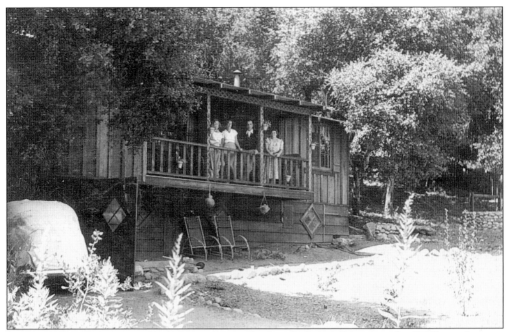

Enjoying a leisurely front porch visit, 1950s-style, from left to right are Evelyn Wallace, Georgia Wallace, Vernon Goold, and Tillie Goold. The Goolds' home was part of the Robles del Rio development, which began in 1926 on the southeast corner of the old Rancho los Laureles. Weekend cabins and permanent homes were built on the subdivision's 600 acres. (Courtesy Jim Goold.)

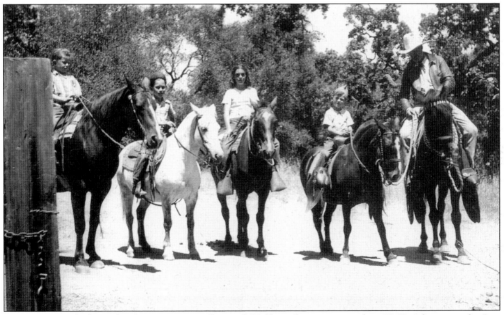

Youngsters ride horseback on a sunny Carmel Valley afternoon in this 1940s photograph. Jim Goold (left) sits astride his steed next to friends (from left to right) Alan Wallace, Alan's cousin Gail Wallace, an unidentified visitor, and cowboy Bob Ford, a former bull and bronco competitor. Ford was mentioned by John Steinbeck in *Cannery Row* as the leader of the Salinas Rodeo parade, a feature Ford initiated in 1911. (Courtesy Jim Goold.)

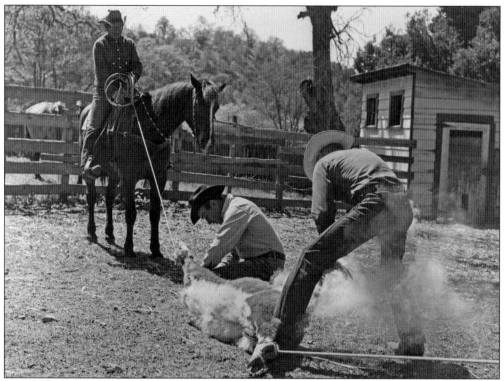

Cattle branding, seen in this 1959 photograph, still took on the same neighborly aspect it had for a century, as a group of Cachagua ranchers help each other at a roundup. Camaraderie and a hearty barbecue were sure to follow the day's work. (Photograph by George T. Smith; courtesy Monterey Public Library, California History Room Archives, Harbick Collection.)

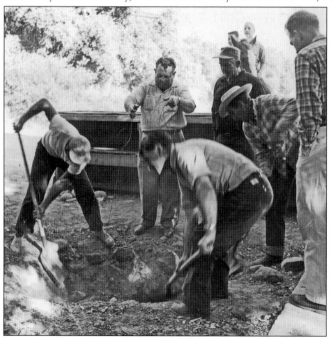

Rex White (rear) holds the lines at a 1959 boar's head feed. Cooks dig up the head after baking it in a hot pit for hours at Prince's Camp. The former rustic resort and campgrounds was located at Cachagua in the Upper Carmel Valley. The hunting camp was founded by Sam Prince in 1925. (Photograph by George T. Smith; courtesy Monterey Public Library, California History Room Archives, Harbick Collection.)

Herb Brownell takes a perfectly cooked wild boar's head out of the coal pit to pass to Sam Corona before it is carried to the carving table to be served to waiting, hungry guests in this late-1950s scene. (Photograph by George T. Smith; courtesy Carmel Valley Historical Society, Julie Risdon Collection.)

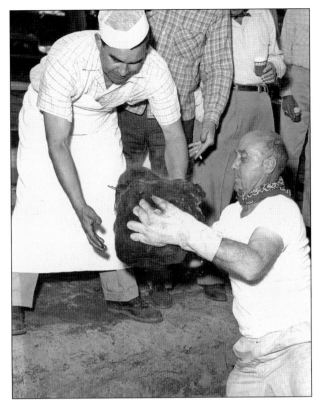

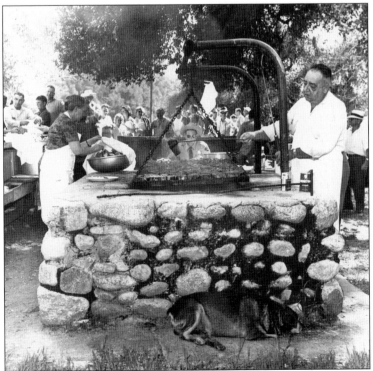

Cliff Keefer oversees a steak barbecue, and traditional Carmel Valley hospitality, at Prince's Camp in 1959. (Photograph by George T. Smith; courtesy Monterey Public Library, California History Room Archives, Harbick Collection.)

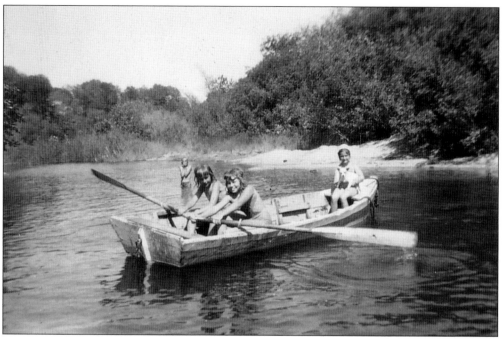

Jennie Wolter Luce (1940–2008), in the bow with her dog, and friends enjoy a leisurely day rowing on the Carmel River in this June 1947 scene at "Wolter's Hole." (Courtesy Russel and Karen Wolter.)

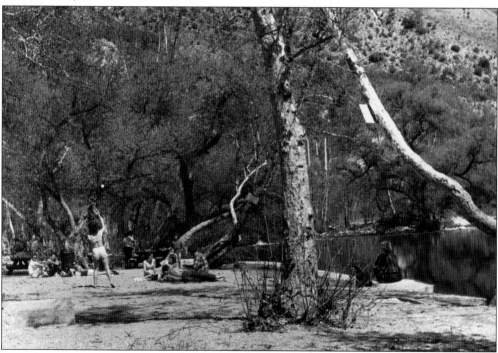

The banks of the Carmel River provide a free and fun spot for friends to gather and sunbathe in this 1949 summer scene. (Courtesy Monterey Public Library, California History Room Archives, Harbick Collection.)

Always ready for a good romp, a group of Valleyites dresses up to pose for the camera at a Halloween party in this October 1950 event sponsored by the Carmel Valley Chamber of Commerce. (Courtesy Carmel Valley Historical Society, Julie Risdon Collection.)

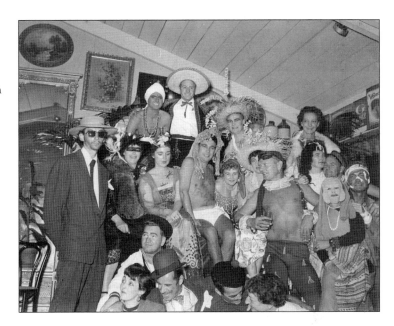

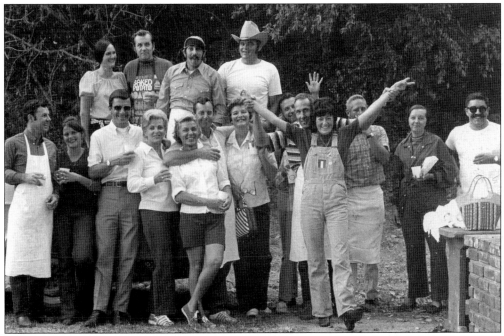

A group of Carmel Valley friends enjoys a c. 1965 barbecue at the Trail and Saddle Club. From left to right are (first row) Larry Busick, Leslie Paddock, Howard Pearson, June Van Hagen, Ruth Allaire, John Woods, June Woods, Ken Van Hagen, Lou Allaire, an unidentified woman, Don Cummings, Regina Corona, and Don Corona; (second row) Barbara Belleci, Bill Broderick, Raz Belleci, and Bill Parham. (Courtesy Carmel Valley Historical Society, Julie Risdon Collection.)

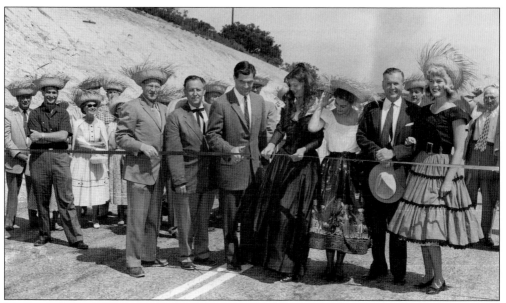

Monterey County supervisor (1954–1962) Burt Talcott cuts a ribbon to inaugurate the rerouted and improved north section of the Laureles Grade (Route G20) at a 1957 ceremony. Designated a California Scenic Route in 1968, the grade was originally a winding wagon road and cattle drive route connecting Carmel Valley to the Monterey-Salinas Highway at Laguna Seca. Supervisor Talcott later became a U.S. congressman (1963–1977). (Courtesy Carmel Valley Historical Society.)

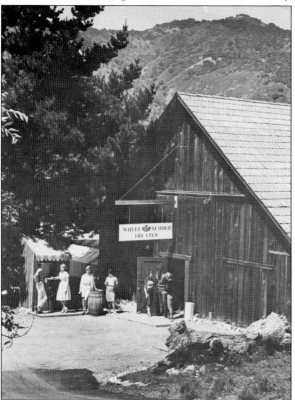

The White Oaks Summer Theatre began in July 1960 in a renovated redwood barn at White Oak Plaza. Like its nearby counterpart, the Tantamount (which later burned), the summer stock theater introduced both actors' training and a regional performance venue to Carmel Valley Village. A new White Oaks Theatre building was dedicated in July 1965 and later became Hidden Valley Music Seminars. (Courtesy Carmel Valley Historical Society, Barbara Marks Collection.)

# Six

# RUSTICATING AT THE RESORTS

For centuries, the mineral waters of Tassajara Hot Springs in Upper Carmel Valley provided a healing source for native Esselen tribes. The remote springs became a tourist spa in 1884 when owner Charles Quilty established a stage route to his remote hotel and bathhouse. Various owners expanded the operation, adding cottages and private mineral baths. Visitors came to hunt, swim, enjoy outdoor sports, and "rusticate," or take in the rural surroundings. Since 1966, the Zen Mountain Center has operated Tassajara as a meditation and work center, with seasonal guests and seminars.

By the 1890s, the Los Laureles Ranch main house was expanded and guest cottages constructed to accommodate Del Monte Hotel guests who endured the four-hour wagon ride from Monterey. The visitors spent weeks enjoying delights of greater Carmel Valley with its salubrious climate, natural ambience, and recreational pursuits such as game hunting, fishing, and canoeing. A Carmel Valley destination, Los Laureles Lodge continues to operate as an upscale resort.

The Robles del Rio Lodge opened in 1928. Built by Frank Porter as a club for residents of his summer home development, for decades the lodge offered members swimming, dining, a 9-hole golf course, tennis court, stables, and a social hall. In 1939, new owners William and Kathleen Wood opened the lodge to the public as a hotel. The property, currently closed, was purchased in 1985 by the Gurries family.

Gordon Armsby's private summer retreat once hosted 1920s Hollywood stars. Clarence Holman purchased the property in 1943 and transformed the acreage into the Holman Guest Ranch with bungalows, stables, and a stone ranch house evocative of a "little San Simeon." During the 1950s and 1960s, guests experienced the pleasures of a working dude ranch. As the only Carmel Valley ranch with a rodeo arena, the locale for several decades hosted horse shows sponsored by the Carmel Valley Horsemen's Association. The property, located east of Carmel Valley Village, continues to function today under new ownership as the Holman Ranch. Boarding stables and a winery complete the elegant picture of yesteryear.

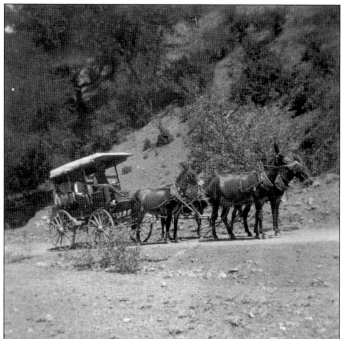

Beginning in 1884, a horse stage carried passengers three times weekly from the Jeffery Hotel in Salinas to Tassajara Hot Springs on a 10- to 12-hour trip up a perilous grade. On the steepest portion, the driver would tie on a log behind the stage to keep it from rolling too fast down the precarious, narrow route. (Courtesy Monterey County Historical Society, Inc.)

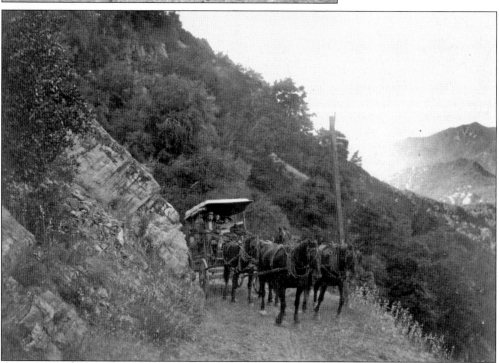

A better road to Tassajara Hot Springs was blasted by Chinese laborers between 1885 and 1890. Four to six horses were required to reach Chew's Ridge, with changes en route at Whitlock's (later K. D. Mathiot's) ranch and at the Lambert ranch. On the steepest portions, the driver pulled the curtains so ladies would not panic at the sight of steep ravines plunging below the narrow stage road. (Courtesy Monterey County Historical Society, Inc.)

The original log Tassajara Hot Springs Hotel, first named Agua Caliente ("hot water" in Spanish), was built in the 1870s by Jack Borden. The final leg of the trip, a trail, led from the James Ranch to the property. Guests hiked, and supplies were packed in. Besides the hotel, amenities included a dining room, some cabins, a camping area, and a bathhouse. (Courtesy Monterey County Free Libraries.)

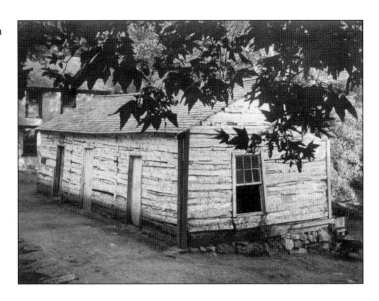

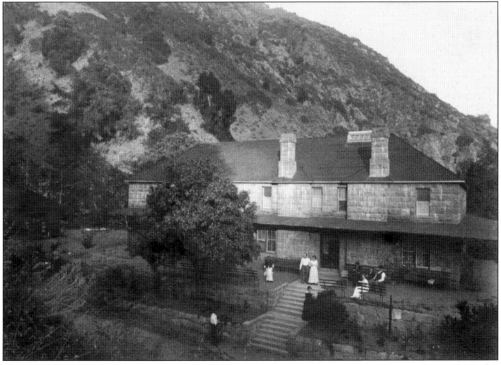

Contented guests pose around 1900 at the main hotel at Tassajara Hot Springs, located on the edge of the Ventana Wilderness at a 5,000-foot altitude in Upper Carmel Valley. A visitor once described the spa as, "A clean and friendly hotel where you are not shot at sunrise if you don't dress for dinner." In time, the management added swimming, outdoor sports, and hunting. (Courtesy Monterey County Free Libraries.)

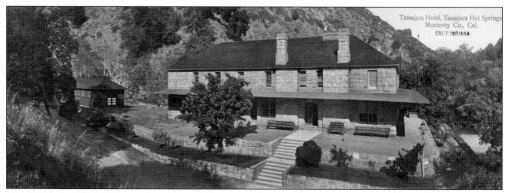

A postcard view shows the Tassajara Hot Springs' "new" hotel, built in 1904 after the first one burned. The spa in 1907 advertised "18 springs, hot sulphur plunges, vapor baths and trout fishing." A telephone line at China Point required drivers to check in with the hotel desk for clearance before proceeding the last 5 miles on the one-way route. (Courtesy Monterey County Free Libraries.)

More than 20 springs, some flowing at 160 degrees from rocky hillsides, served health-seekers at Tassajara Hot Springs. The establishment touted a salubrious mineral content in the water, including sulfur, sodium, magnesia, iron, and phosphates. The resort claimed its resources were equal to the best European mineral springs. (Courtesy Monterey County Free Libraries.)

Riding the first automobile to make a round-trip between Salinas and Tassajara around 1912 is John Talbott Masengill (back seat, right). Other passengers are listed as Abellaroe Cooper, LeRoy Goodrich (a reporter), and a Mr. Close. Wiley Thomas Masengill took the picture. Daily auto stage service began in 1914. The driver left Salinas in the morning, arriving at Tassajara at 4:00 p.m. (Courtesy Monterey County Historical Society, Inc.)

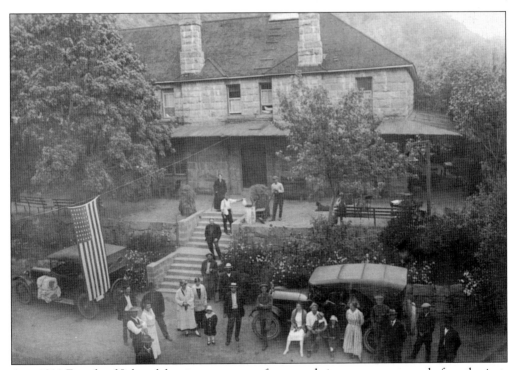

A c. 1914 Fourth of July celebration was cause for a good time as guests pose before the just-arrived Tassajara auto stage. Besides hot baths and massages, a dining room offered ample meals for guests, who enjoyed daytime activities such as hiking, croquet, horseshoes, piano playing, and card games. Evening dance music was provided by a windup phonograph. (Courtesy Monterey County Free Libraries.)

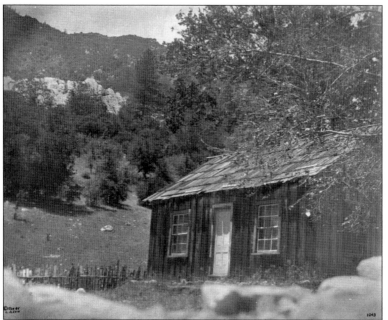

A mountain cabin sits below the arduous route to the caves beyond Tassajara Hot Springs in this 1920 photograph. For centuries before the white man arrived, Esselen Indians used the springs for curative purposes. The area was said to be good for drying meat, which gave rise to its name, Tassajara, or "a place to dry meat." (Courtesy Monterey County Free Libraries.)

Beyond Tassajara, Santa Lucia Peak appears through Coulter Pines above a rocky ravine in this 1920 photograph. Esselen Indians occupied small villages in the rugged mountain region for several thousand years and left rock art inside remote caves. The first group to become culturally extinct following the secularization of Mission Carmel, the Esselen population for centuries had lived by hunting and gathering. (Courtesy Monterey County Free Libraries.)

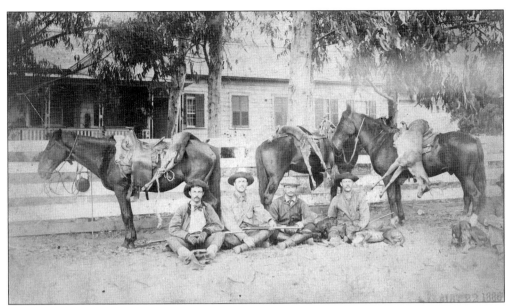

Manager William Hatton (right) poses on August 22, 1886, with a hunting party in front of Los Laureles Lodge. From 1882, the Pacific Improvement Company provided the ranch's dairy products to guests at its Del Monte Hotel in Monterey. By 1890, the ranch buildings had become an out-camp and lodge for Del Monte hotel guests who spent weeks relaxing at the rustic accommodations. (Marcia DeVoe Collection; courtesy Harrison Memorial Library.)

Los Laureles Lodge, seen in this 1912 photograph, evolved into a comfortable country resort with amenities such as swimming and fine dining. Over the decades, both locals and guests have continued to patronize and enjoy the lodge and its restaurant. (Courtesy Pat Hathaway, California Views.)

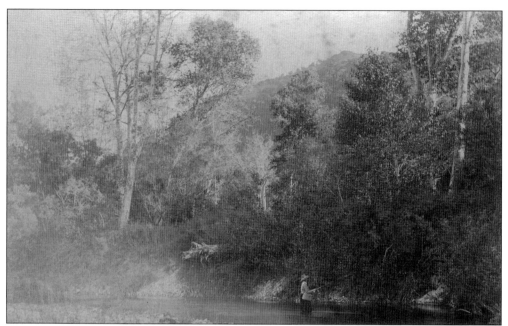

For the locals, resort-style living came for free, with seasonal outdoor sports and social activities. Here William Hatton's daughter Anna fishes in the nearby Carmel River at Los Laureles Ranch in 1886. The river was famous for an abundant run of steelhead trout, which is now a protected species. (Marcia DeVoe Collection; courtesy Harrison Memorial Library.)

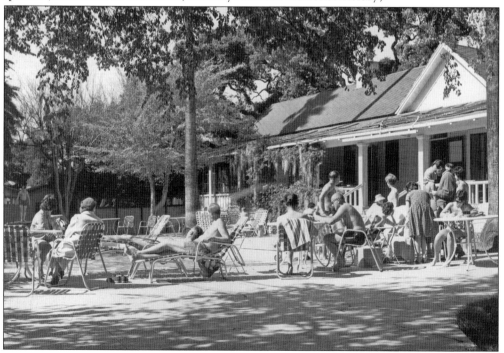

A group of sun seekers enjoys the upgraded swimming pool and patio area along with the historic ambiance at Los Laureles Lodge in this 1962 scene. (Courtesy Monterey Public Library, California History Room Archives, Harbick Collection.)

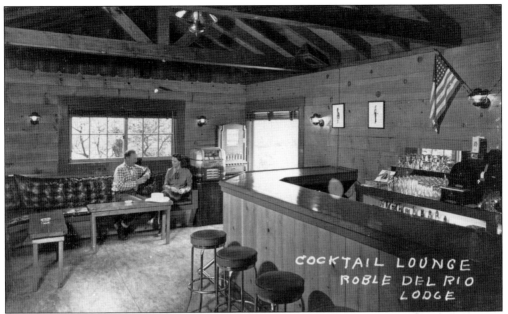

Robles del Rio Lodge began in 1932 as a semi-private recreational club catering to residents of the Robles del Rio development and to non-property owners. Guests pause on a 1943 afternoon to enjoy a libation in the cocktail lounge, called the Cantina, in this postcard scene. The bar, which opened in 1937, was granted Carmel Valley's first liquor license. (Courtesy Pat Hathaway, California Views.)

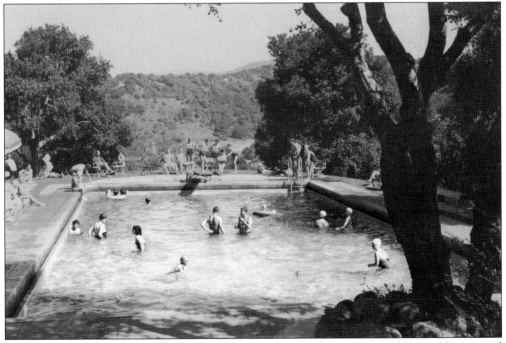

Besides golf, tennis, horseback riding, and dining, both club members and the public enjoyed the popular Robles del Rio swimming pool, pictured here in a 1940s postcard. (Courtesy Pat Hathaway, California Views.)

Clarence Holman (died 1962), son of the founder of Holman's Department Store in Pacific Grove, purchased the Gordon Armsby ranch property in 1943. He and his wife, Vivian, built the property into a showpiece ranch. During the 1950s and 1960s, the Holman Guest Ranch was the center of Carmel Valley social life. (Courtesy Holman Ranch collection.)

The Holman Guest Ranch main house, pictured, began in the 1920s as a private home and retreat built by Gordon Armsby, a member of the Monterey Peninsula's elite. The country estate was said to have been a hideaway for Hollywood celebrities Charlie Chaplin and Theda Bara. (Photograph by Richard Barratt.)

Furnishings and appointments at the Holman Ranch, such as in the living room pictured here, have been refurbished to appear much as they did during the early years when Hollywood stars favored the ranch as a private hideaway. (Photograph by Richard Barratt.)

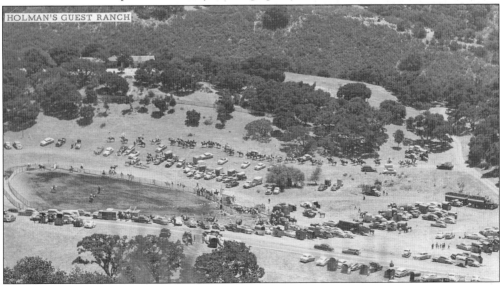

The show arena at the Holman Guest Ranch was the Carmel Valley venue for horse shows, rodeos, and other equestrian events. Here cars are parked around the arena as visitors gather to watch a 1950s show sponsored by the Carmel Valley Horsemen's Association. (Courtesy Carmel Valley Historical Society.)

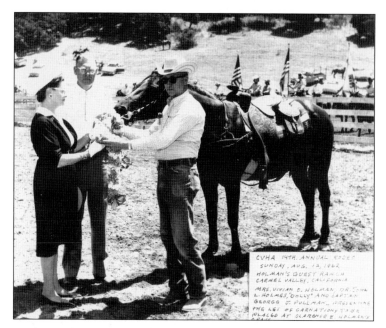

Vivian Ogden Holman (1903–1981) presents Capt. George Pullman a carnation lei at the 14th Annual Carmel Valley Horsemen's Association Rodeo on August 12, 1962. The lei was to be placed on Clarence Holman's grave. For decades following her husband's death, Holman operated the combination dude and working ranch on her own. (Courtesy Carmel Valley Historical Society.)

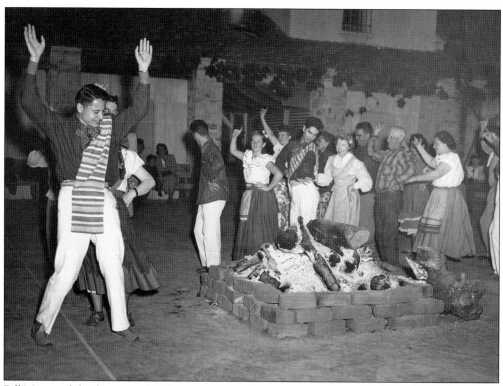

Bill Marquardt leads a Carmel Valley dance group at the Homan Guest Ranch on a hot August night in 1950. The ranch hosted an annual Fiesta de los Amigos, as well as dances and numerous theme parties over the years. (Courtesy Carmel Valley Historical Society, Julie Risdon Collection.)

Models pose in the 1950s at Rancho San Carlos, today a private community and originally part of two Mexican grants, El Potrero de San Carlos and San Francisquito. Owners Bradley Sargent (1876), George Gordon Moore (1924), and Arthur Oppenheimer (1939) variously added a Hacienda-style private guest lodge (background), a lake, a polo field, stables, and a cattle ranch. Guests enjoyed hunting wild boar, which Moore introduced to Carmel Valley. (Courtesy Carmel Valley Historical Society.)

Locals and vacationers were doubtless drawn by an 1881 description of Carmel Valley's sportsmen's pursuits: "In the mountain streams of the Carmel River there is fine trout-fishing. Quails, rabbits and hares are abundant, and deer and bear are found in the hills and towards the coast." Here Abe McFadden poses around 1928 while on a hunting trip at Garzas Ranch. (Courtesy Monterey Public Library, California History Room Archives.)

This intriguing 1889 scene, "Bluffs on Carmel River," was originally sold as a stereoscopic view. Photographer C. W. J. Johnson portrays a group of hikers enjoying a rest following the steep cliff-side climb above the Carmel River to enjoy the valley and mountain views. (Courtesy Monterey Public Library, California History Room Archives.)

A group of happy campers in 1886 poses at Eagle Camp, a popular spot later known as Camp Steffani, located east of Carmel Valley Village. Day-trippers and camping parties would drive their wagons along the Carmel River to the picnic and tenting spot to hunt, fish, and tour the countryside. (Courtesy Monterey County Historical Society, Inc.)

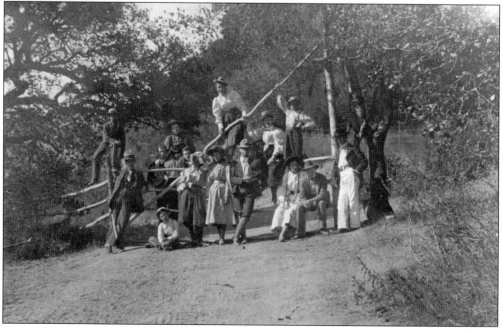

# Seven

# FAMOUS FACES THROUGH TIME

The first famous visitor to Carmel Valley, explorer Sebastian de Vizcaíno, briefly visited the area in 1603. He found elk, an abundance of trees and foliage, and a deserted Native American village on the north bank of the Carmel River. It would be 166 years before another historic figure, Don Gaspar de Portolá, passed through the area on his first expedition to rediscover Vizcaíno's Monterey Bay.

Over the centuries since, Carmel Valley has seen its share of the famous come and go. While the area was largely considered a place of ranches and farms, and perhaps good for a camping getaway, the valley's ambiance and natural appeal had their own draw and evolved in a quieter but parallel way. Many famous people have been drawn to visit the valley. Some made the stay permanent.

One brief visitor was writer Robert Louis Stevenson, who started out on a camping trip to Carmel Valley on September 9, 1879. He had traveled from Scotland to visit his life's love, Fanny Osbourne, who was temporarily staying in Monterey. After driving his wagon far up Robinson Canyon Road, he fell ill with a fever. He lay in a stupor for two days beneath a tree before being discovered and rescued by Jonathan Wright, a goat herder. Stevenson later wrote of the experience.

During the 1920s–1940s, especially during the Prohibition era, the private lodges at the Holman Guest Ranch and at Rancho San Carlos hosted the elite of the era San Simeon–style. A short guest list included Hollywood stars such as Clark Gable, Rita Hayworth, Vincent Price, Marlon Brando, Gene Autry, Joan Crawford, and Robert Young. Among those who settled in the valley were Betty MacDonald, the author of *The Egg and I*, golf champion Marion Hollins, racehorse breeder Muriel Vanderbilt Phelps, and several movie stars.

On the following pages are but a few of the colorful figures who have passed this way over time, drawn by the valley's enchanting appeal to the simple but abundant life.

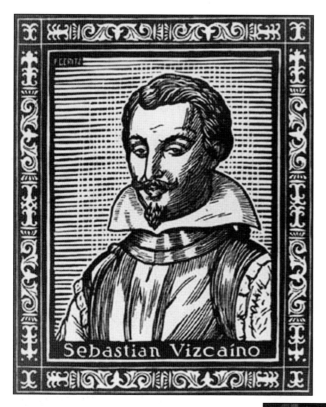

Sebastian Vizcaíno

Spanish explorer Sebastian de Vizcaíno (c. 1550–c. 1628) discovered Carmel Valley on his expedition's final day, January 3, 1603. With Father Andrés de la Asunción and a group of arquebusiers, he marched over a hill from Monterey to the mouth of Carmel Valley and discovered a flowing river, which he named the Rio Carmelo after the Carmelite friars who accompanied the voyage. (Courtesy Monterey Public Library, California History Room Archives.)

Don Gaspar de Portolá (c. 1723–1784) led two expeditions (1769 and 1770) to discover Monterey Bay; the second one was successful. Along with Padre Serra, he was present in Monterey at the founding of the Presidio and the first Mission San Carlos Borromeo, which was later transferred to Carmel Valley. (Courtesy Monterey Public Library, California History Room Archives.)

Bandito Tiburcio Vasquez (1835–1875) was a notorious stage robber, but the Monterey-born desperado was also considered a courtly gentleman. He reputedly visited his brother, Antonio Marie Vasquez (1826–1889) and his wife, Asunción Boronda (1829–1901), at their Carmel Valley ranch. Following a triple murder in Tres Pinos, Vásquez was caught and tried. He was found guilty and hanged in San José on March 19, 1875. (Courtesy Pat and Kate McAnaney.)

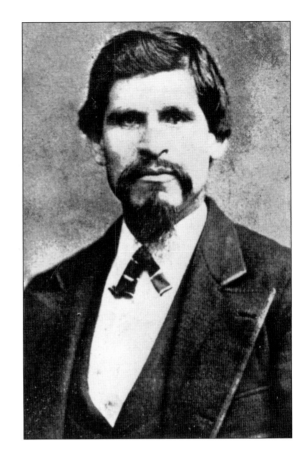

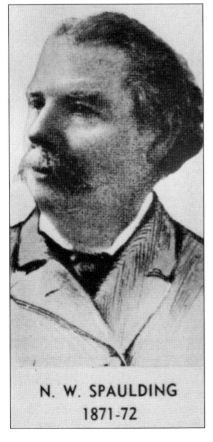

N. W. SPAULDING
1871-72

Oakland's 15th mayor, saw tooth inventor, and gentleman rancher Nathan Weston Spaulding (1829–1903) owned Rancho los Laureles from 1874 to 1881. During his ownership, many modern farming and dairying improvements, as well as modern irrigation and fencing, were introduced for the first time in Carmel Valley. (Courtesy Oakland Public Library, Oakland History Room.)

In March 1930, famed aviator Charles Lindbergh (center) is surrounded by a group of admirers as he prepares to test launch a sailplane from a hill at Sydney Fish's Palo Corona Ranch, located at the mouth of Carmel Valley. (Photograph by William L. Morgan; courtesy Monterey Public Library, California History Room Archives.)

Aloft over Carmel Valley in March 1930, Charles Lindbergh appears in the cockpit of his Bowlus sailplane. (Photograph by William L. Morgan; courtesy Monterey Public Library, California History Room Archives.)

World-renowned Carmel poet Robinson Jeffers, seen in this c. 1950 portrait, wrote evocative, personal works on nature, the cosmos, and human connections. Several of his poems were set in Carmel Valley. (Photograph by Sadie Adriane; courtesy Monterey Public Library, California History Room Archives, Harbick Collection.)

Salvador Dali, photographed in 1947 in his Monterey Studio on the ranch of Col. Howard Mack, spent several nights camping out at the Boronda Adobe property. During the stay, he camped and sketched near a large eucalyptus tree. (Photograph by Rey Ruppel; courtesy Monterey Public Library, California History Room Archives.)

Cartoonist Hank Ketcham (1920–2001), left, and sculptor Arch Garner (1904–1969) decorate Joan Jones for a 1950s Beaux Arts Costume Ball in Carmel Valley. Ketcham lived at Rancho el Robledo, near Rosie's Cracker Barrel. He hung out with Rosie's regulars, using them as occasional characters in his *Dennis the Menace* cartoons, which ran 1951–1994. Garner designed Monterey's Dennis the Menace playground. (Photograph by George T. Smith; courtesy Carmel Valley Historical Society, Julie Risdon Collection.)

Fred Toole (left), seen being interviewed in about 1970, was Hank Ketcham's associate and wrote the farcical but realistic script for the *Dennis the Menace* cartoons. Toole was known in cartoon circles for his witty and inventive writing. A framed Ketcham drawing of him appears in the upper right corner of the photograph. (Courtesy Carmel Valley Historical Society, Julie Risdon Collection.)

Frank O'Neal (1921–1986), creator of the *Short Ribs* comic strip, which ran from 1958 to 1973, poses at his desk in an undated photograph. O'Neal lived in Robles del Rio and, along with Hank Ketcham, was a frequent visitor to Rosie's Cracker Barrel. (Courtesy Carmel Valley Historical Society, Julie Risdon Collection.)

Noted 1930s magazine illustrator and jazz enthusiast Al Parker (1906–1985) poses with his saxophone in this undated photograph. Parker earned his way through college playing saxophone, clarinet, and drums and operated his own band on a riverboat cruise. He lived in Carmel Valley from 1955 to 1985. (Courtesy Carmel Valley Historical Society, Julie Risdon Collection.)

Pres. and Mrs. Dwight D. Eisenhower visit with Msgr. Michael O'Connor on August 26, 1956, in the courtyard of Mission Carmel. Nuns of the Notre Dame order pose in the background while two unidentified clergymen observe the scene. (Photograph by William L. Morgan; courtesy Monterey Public Library, California History Room Archives.)

Del Monte Properties founder Samuel F. B. Morse (left) and Pres. Dwight D. Eisenhower pose for the camera at "The President Plays Golf Day" in October 1956 at Cypress Point in Pebble Beach. Morse was a grandnephew of the inventor of the telegraph. He purchased the Pacific Improvement Company's holdings in 1919, including those in Carmel Valley. (Photograph by Julian P. Graham; courtesy Monterey Public Library, California History Room Archives, Harbick Collection.)

Writer John Steinbeck (1902–1968) included a Carmel Valley episode in his 1945 novel, *Cannery Row*. Characters Mack and the boys go on a frog-catching expedition to the Carmel River, planning to sell the catch to Doc Ricketts for his lab, thus earning money to throw Doc a party. Steinbeck also mentions Carmel Valley's Laureles Grade in his 1932 novel, *The Pastures of Heaven*. (Courtesy Pat Hathaway, California Views.)

Marine biologist Edward Ricketts (1897–1948), owner of Pacific Biological Laboratories on Monterey's Cannery Row, poses by his car on a visit to Carmel Valley. Ricketts, who became friends with John Steinbeck in 1930, served as inspiration for the character Doc Ricketts in several of Steinbeck's novels, notably *Cannery Row* and *Sweet Thursday*, and his nonfiction work, *The Log from the Sea of Cortez*. (Courtesy Pat Hathaway, California Views.)

Folk singer Joan Baez, seen here performing at a 1964 concert at Monterey Peninsula College, was living in Carmel Valley when she founded the Institute for the Study of Non Violence. The school offered peace seminars. Classes were held from 1965 to 1969, when Joan and her husband, David Harris, and the institute moved to Palo Alto. (Photograph by Joseph Johnson; courtesy Monterey Public Library, California History Room Archives.)

Carmel Valley veterinarian Gerald Petkus became a subject of Joan Didion's essay "Where the Kissing Stops" in her 1968 volume, *Slouching Towards Bethlehem*. Petkus and other residents feared that Joan Baez's Institute for the Study of Non Violence would disrupt the valley by encouraging an unsavory beatnik lifestyle. They unsuccessfully protested the singer's application for a county use permit to operate the school. (Courtesy Carmel Valley Historical Society.)

Former Carmel mayor, screen actor, director, and producer Clint Eastwood appears at a 1971 Pebble Beach Celebrity Tennis Tournament. Eastwood owns a golf community in Carmel Valley and saved the pioneer Martin family's former Mission Ranch property from being razed for a development. Segments from his 1971 movie, *Play Misty for Me*, were filmed at the former KRML radio studio at the mouth of the valley. (Courtesy Ellsworth Gregory.)

Popular entertainer and television talk show host Merv Griffin (1925–2007), seen here at a 1971 celebrity tennis tournament, purchased a ranch in Carmel Valley in 1986. He planted a vineyard on his extensive acreage and often entertained Hollywood celebrities. When in residence, he was frequently seen at restaurants in Carmel Valley with his lady friend Eva Gabor. (Courtesy Ellsworth Gregory.)

Carmel Valley resident Leon Panetta appears in this 1990 photograph as grand marshal of Monterey's Fourth of July parade. Panetta is a former U.S. congressman (1977–1993) and White House Chief of Staff (1994–1997). He currently serves as director of the Central Intelligence Agency in Washington, D.C. (Photograph by Joseph Johnson; courtesy Monterey Public Library, California History Room Archives.)

Actress and singer Doris Day left Hollywood to become a Carmel Valley resident nearly 30 years ago. She founded the Doris Day Animal Foundation, the Doris Day Animal League (which recently merged with the Humane Society of the United States), and owns a pet-friendly Carmel hotel. Day gave this photograph to the wife of the former president of the Carmel Valley Historical Society. (Courtesy Ellsworth Gregory.)

# *Eight*

# PRESERVING OUR PAST

In his 1880 essay "The Old Pacific Capital," Robert Louis Stevenson expressed a foreboding sense that Carmel Valley was on the brink of change: "In comparison between what was and what is in California, the praisers of times past will fix upon the Indians of Carmel. The valley, drained by the river so named, is a true Californian valley, bare, dotted with chaparral, overlooked by quaint, unfinished hills. The Carmel runs by many pleasant farms, a clear and shallow river, loved by wading kine; and at last, as it is falling towards a quicksand and into the great Pacific, passes a ruined mission on a hill . . . but the day of the Jesuit has gone by, the day of the Yankee has succeeded, and there is no one left to care for the converted savage. . . . their lands, I am told, are being yearly encroached upon by the neighbouring American proprietor."

Stevenson summed up the view of many who have passed through Carmel Valley over the decades since his brief visit and who have witnessed the carving up of the land into smaller parcels. Although progress cannot be halted, the destruction of past history can be contained when residents and concerned parties come together in the name of shared appreciation of our common heritage.

One resident summed it up this way: "I was upset over the burning 'for practice' of the old Chatterbox restaurant some years ago. It was a real old Western style building with overhanging roof and railing around the porch to tie horses to. We can't let these historical sites go the way of modern progress."

Citizens' efforts in recent decades have raised public awareness of the need to preserve Carmel Valley's past, from old homes and barns, to a row of 130-year-old blue gum eucalyptus trees, to the once prolific, now endangered steelhead trout, which run in season down the Carmel River.

Sadly, it is too late for the cabin where Stevenson stayed. Only a stone chimney remains from the historic home, which over the past decade has been left to fall in and crumble away.

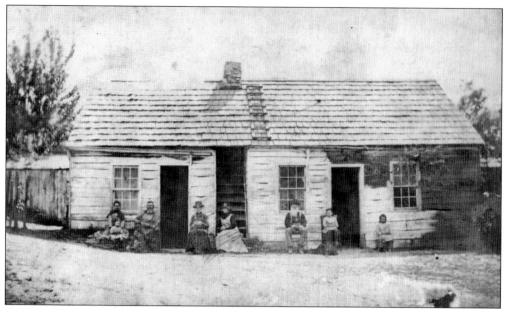

The Wright-Stevenson Cabin, sometimes called the Smith-Wright cabin, belonged to Jonathan Wright, a former ship's captain turned goat herder. Wright appears on the left with his wife and youngest child in the 1880s. His partner, white-bearded Anson Smith, sits center with his wife and daughter. Two of Wright's other children sit to Smith's right. (Courtesy Monterey Public Library, California History Room Archives.)

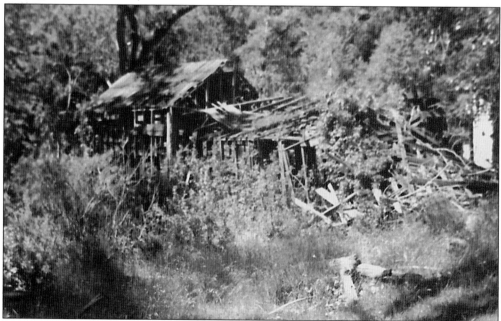

This 1991 photograph shows the nearly collapsed Wright-Stevenson cabin, Here, in 1879, the fever-laden Robert Louis Stevenson recuperated in a cowhide-covered bed. "I am lying in an upper chamber nearly naked, with the flies crawling all over me and a clinking of goat bells in my ear," he wrote to a friend. Except for a lonely chimney, the cabin is now completely gone. (Photograph by Richard Barratt.)

Pioneer Edward Berwick's 1869 barn provides picturesque material for these 1950s landscape artists. In 1879, Robert Louis Stevenson spent the night sleeping on hay inside the barn while on his way up Robinson Canyon Road to camp. Although the Berwick property is on the National Register of Historic Places, the barn fell into ruin and is no longer present. (Courtesy Carmel Valley Historical Society, Julie Risdon Collection.)

This modern Carmel Valley home was designed for Joan Baez by architect John Howard Gamble (1911–1997). The popular folk singer lived in the eclectic residence from 1964 to 1968. During part of the time, she was romantically linked with singer Bob Dylan. The home's current owners applied for Monterey County Register of Historic Resources status, which was granted in 2009. (Courtesy Kent Seavey.)

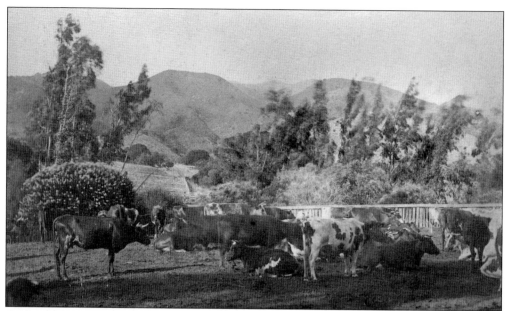

A placid 1886 scene, "Dairy Pasture, Los Laureles Ranch," shows cattle grazing at Boronda and Carmel Valley Roads. A twin row of blue gum eucalyptus (rear) was planted during Oakland mayor Nathan Spaulding's ownership (1874–1881). A century later, the trees became a topic of heated local controversy. Since 1985, ongoing efforts by Monterey County to remove the historic tree row have stirred lively debate. (Marcia DeVoe Collection; courtesy Harrison Memorial Library.)

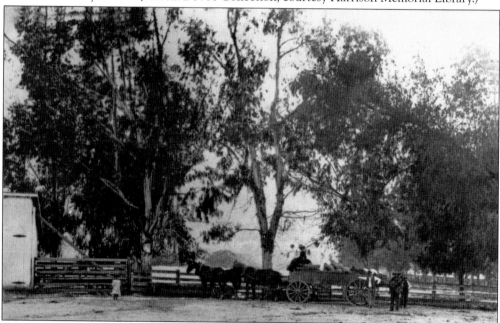

In 1898, the Boronda Road eucalyptus row appears in the right rear of Charles W. J. Johnson's photograph. Flora Steffani sits in the lumber wagon; Sarah Hatton is on the left. Standing from left to right are Joseph Steffani, Joseph Hitchcock Sr., and Alex Escobar, a nephew of Loretta Meadows. The scene is photographed across Carmel Valley Road from Los Laureles Lodge. (Courtesy Pat Hathaway, California Views.)

120

In 1948, the 75-year-old Boronda Road eucalyptus trees, seen from a vantage point along Carmel Valley Road, are still going strong. By February 1957, after much debate over whether the trees posed a traffic hazard, the Carmel Valley Property Owner's Association voted overwhelmingly to retain them. (Courtesy Monterey Public Library, California History Room Archives, Harbick Collection.)

In 2007, following the most recent attempt by Monterey County to chop them down, a group of citizens applied for historic status for the venerable Australian blue gums. On January 10, 2008, the 130-year-old Carmel Valley Road–Boronda Road Eucalyptus Tree Row was successfully placed on the National Register of Historic Places. (Photograph by Richard Barratt.)

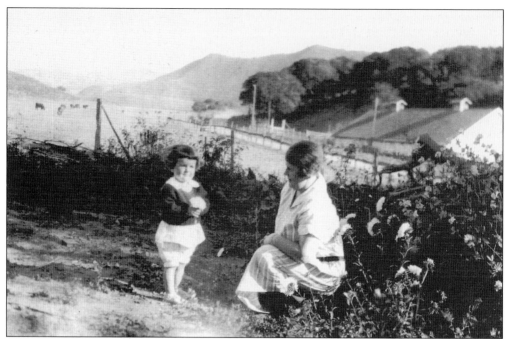

The Hatton Middle Dairy Barn, which dates to 1890, is pictured in 1925 with Frank Hatton's wife, Irene, and daughter Harriet in the foreground. Frank was the son of Carmel Valley pioneers William and Kate Hatton. (Courtesy Kent Seavey, Gordon Martin Collection.)

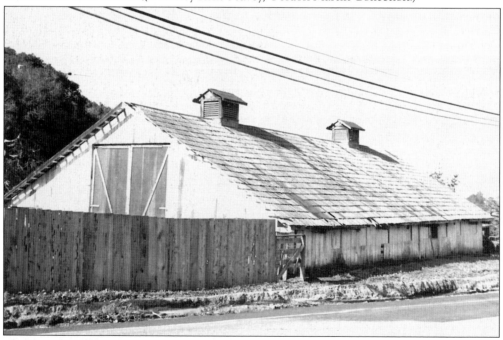

The Hatton Middle Dairy Barn, located on Carmel Valley Road, appears in this 1980 photograph. The structure is the last of the Hatton barns still standing. The current property owner is involved in preservation efforts to save the barn, built during the Hatton family's dairying era. (Marcia DeVoe Collection; courtesy Carmel Valley Historical Society.)

The ruins of an old adobe at Rancho los Tularcitos, located east of the present Carmel Valley Village, were photographed in 1918 by L. S. Slevin. The adobe may have been part of the ranch house of the original grantee, Rafael Gómez. (Courtesy Carmel Valley Historical Society, Don Howard Collection.)

During the 1970s, the Rancho los Tularcitos adobe and environs were researched by archaeology buff Don Howard (left). Excavations revealed foundations and artifacts from the rancho's early days. (Courtesy Carmel Valley Historical Society, Don Howard Collection.)

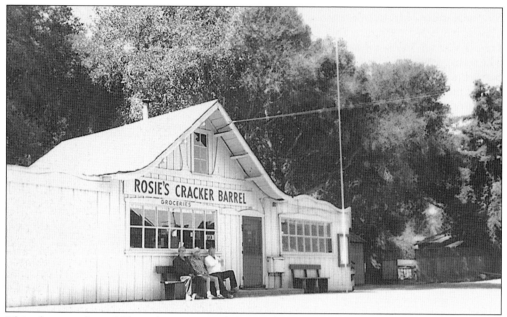

This photograph could have been snapped during the 1940s, 1950s, 1960s, 1970s, and into the 1980s. Given a fine day, "the gang at Rosie's Cracker Barrel," seen here in 1980, meant just about anyone Rosie knew who sat out front of the store and watched life pass by along Esquiline Road, located just off Carmel Valley Road. Rosie's continues to be maintained by the present owners. (Courtesy Carmel Valley Historical Society.)

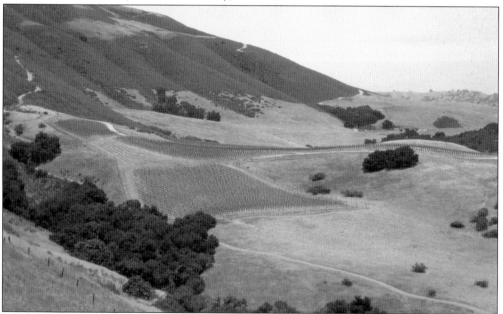

Young vineyards grow on the hillsides of the Holman Ranch, part of an ever-expanding wine industry in Carmel Valley. Grape culture merited but a mention in a 1915 Monterey County promotional booklet, which noted that several small vineyards had been planted in Carmel Valley, "as evidence of a thrifty culture." Today the valley's boutique winery tasting rooms cater to both locals and tourists. (Photograph by Richard Barratt.)

*Madonna of the Oaks*, a sculpture by Djey Owens, has been a feature at White Oak Plaza in Carmel Valley Village since 1962. The statue, originally commissioned by a Santa Barbara church, had been rejected. Owens brought his work to Carmel Valley and installed it at the plaza. The beloved Madonna received ecumenical blessings from local clergy in 1964 and was rededicated in 1971. (Photograph by Richard Barratt.)

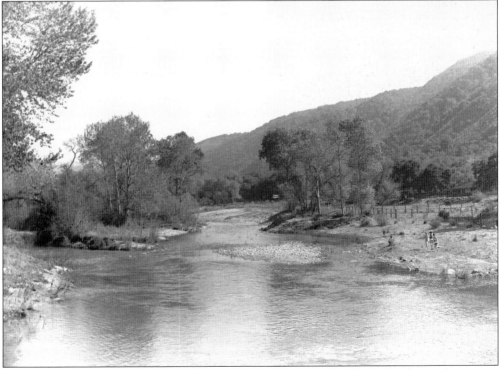

Flowing along through time, the life-giving Carmel River courses to the sea, evoking a description from the 1881 *History of Monterey County with Illustrations*: "Silvery sands line the bay, whiter almost than the sea-foam as it splashes against the dark background. The beautiful, clear Carmelo River glistens in the sunlight as it empties its pure waters in this bay, to be lost in the vast ocean." (Photograph by George Seideneck; courtesy Carmel Valley Historical Society.)

# BIBLIOGRAPHY

Breschini, Gary S., and Trudy Haversat. *The Esselen Indians of the Big Sur Country: The Land and its People*. Salinas, CA: Coyote Press, 2004.

Brewer, William; Francis P. Farquhar, ed. *Up and Down California in 1860–1864*. Berkeley, CA: The University of California Press, 1966.

Chase, J. Smeaton. *California Coast Trails: A Horseback Adventure from Mexico to Oregon, 1913*. Palo Alto, CA: Tioga Publishing Company, 1987.

Colton, Walter. *Three Years in California*. New York: A. S. Barnes and Company, 1850.

Copeland, Dennis, and Jeanne McCombs. *A Monterey Album: Life by the Bay*. San Francisco: Arcadia Publishing, 2003.

Culleton, James. *Indians and Pioneers of Old Monterey*. Fresno, CA: Academy of California Church History, 1950.

Cutter, Donald C. *California in 1792*. Norman, OK: University of Oklahoma Press, 1990.

Fink, Augusta. *Monterey County, The Dramatic Story of its Past*. Santa Cruz, CA: Western Tanager Press, 1972.

*History of Monterey County with Illustrations*. Elliott and Moore, Publishers, 1881. Facsimile reproduction, Valley Publishers, Fresno, CA, 1979.

La Perouse, Jean Francois; Malcolm Margolin, ed. *Monterey in 1786*. Berkeley, CA: Heyday Books, 1989.

Margolin, Malcolm. *The Ohlone Way: Indian Life in the San Francisco–Monterey Bay Area*. Berkeley, CA: Heyday Books, 1978.

Older, Mrs. Fremont. *California Missions and Their Romances*. New York: Coward-McCann, Inc., 1938.

Thomas, Donald. *Monterey County Place Name: A Geographical Dictionary*. Carmel Valley, CA: Kestrel Press, 1991.

Van Nostrand, Jeanne. *Monterey: Adobe Capital of California*. San Francisco, CA: California Historical Society, 1968.

# ABOUT THE CARMEL VALLEY HISTORICAL SOCIETY

The Carmel Valley Historical Society, formed in 1987, is committed to the preservation of the valley's rich and unique heritage. Among its members are both longtime residents and newcomers, all sharing a common bond: a love of Carmel Valley, its pace of life, devotion to maintaining the valley's rural atmosphere, and a desire to help protect the area's natural and human history.

Over the years, individuals have donated an extensive collection of Native American artifacts, heirloom family photographs, antique tools, and vintage farm equipment to the society. The collection also includes audio-taped oral histories of early Carmel Valley residents, scrapbooks from pioneer families, extensive newspaper clippings, artwork by local craftsmen, books, maps, antique clothing, and cowboy gear. Among the notable contributions is an extensive professional photography collection from the 1940s by artist-photographer George Seideneck. The collection shows scenes of the valley landscape "as it was," devoid of homes but dotted with stretching scenes of cattle and orchards. Another asset is an antique rosewood square grand piano, the first in Carmel Valley, which arrived "around the Horn" in 1870 along with the pioneer Hatton family. The society has in its collection more than 750 photograph negatives of Carmel Valley topics from past issues of the former publications, the *Carmel Valley Outlook* and the *Carmel Valley News*. The society has also begun the task of photographing and documenting the oldest buildings in the valley.

The Carmel Valley Historical Society is a member of the Conference of California Historical Societies and the Carmel Valley Chamber of Commerce.

Ground was broken on January 5, 2009, for the Carmel Valley History Center. Designed to resemble one of the numerous barns that once dotted the valley floor, the center sits on donated land adjacent to the Community Park, on Carmel Valley Road in the heart of Carmel Valley Village.

Proceeds from sales of this volume will go to support the Carmel Valley Historical Society's History Center and other outreach efforts, which help preserve and maintain local historic resources.

For more information, contact: The Carmel Valley Historical Society, P.O. Box 1612, Carmel Valley, CA 93924; carmelvalleyhistory.blogspot.com.

# www.arcadiapublishing.com

MAP SEARCH

Discover books about the town where you grew up, the cities where your friends and families live, the town where your parents met, or even that retirement spot you've been dreaming about. Our Web site provides history lovers with exclusive deals, advanced notification about new titles, e-mail alerts of author events, and much more.

**MADE IN THE USA**

Arcadia Publishing, the leading local history publisher in the United States, is committed to making history accessible and meaningful through publishing books that celebrate and preserve the heritage of America's people and places. Consistent with our mission to preserve history on a local level, this book was printed in South Carolina on American-made paper and manufactured entirely in the United States.

This book carries the accredited Forest Stewardship Council (FSC) label and is printed on 100 percent FSC-certified paper. Products carrying the FSC label are independently certified to assure consumers that they come from forests that are managed to meet the social, economic, and ecological needs of present and future generations.

**FSC**
**Mixed Sources**
Product group from well-managed
forests and other controlled sources

Cert no. SW-COC-001530
www.fsc.org
© 1996 Forest Stewardship Council

Find Your Place in History.